THE AMATEUR

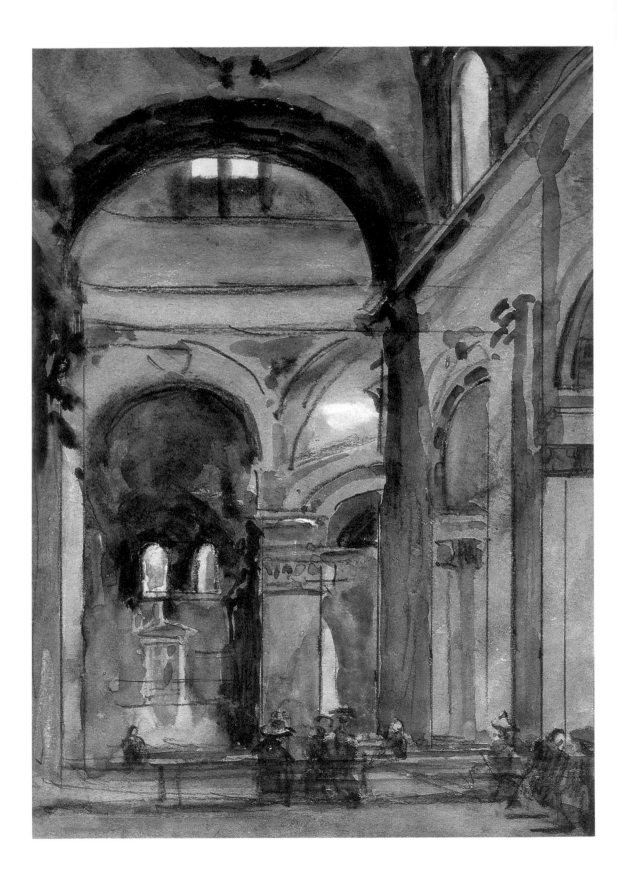

Lord Thorneycroft

THE AMATEUR

A Companion to Watercolour

Foreword by Sir Hugh Casson

To Albert.
with best wishes.

Thorneycroft. Nov '85

SIDGWICK & JACKSON
LONDON

First published in Great Britain in 1985
by Sidgwick & Jackson Limited

Copyright © 1985 by Lord Thorneycroft

Design by James Campus

Picture research by Annie Horton

ISBN 0–283–99246–8 (hardcover)
ISBN 0–283–99318–9 (softcover)

Phototypeset by Falcon Graphic Art Ltd
Wallington, Surrey
Printed in Great Britain by
W.S. Cowell Ltd, Butter Market, Ipswich
for Sidgwick & Jackson Limited
1 Tavistock Chambers, Bloomsbury Way
London WC1A 2SG

Frontispiece: 1 *Interior, St Paul's*,
SIR WILLIAM EDEN
An amateur of almost everything

CONTENTS

page 6 Acknowledgements

9 Foreword

11 THE AMATEUR

17 WATERCOLOUR

26 LEARNING

32 DRAWING AS A MEANS

43 DRAWING AS AN ART

48 PAINTING

58 BEYOND TECHNIQUE

68 PAST MASTERS

78 THE VICTORIANS AND AFTER

88 AMATEURS OF THE GOLDEN AGE

113 THE CONTINUING TRADITION

122 DISTINGUISHED AMATEURS

133 THE DRAWING MASTERS

138 THE COMPANIONSHIP OF PAINTING

144 Notes

146 Museums and Art Galleries

152 Bibliography

153 List of Illustrations

155 Index

ACKNOWLEDGEMENTS

A man who writes a book rapidly finds the limit of his knowledge. In the search for information I have certainly learned much that I did not know before. I am much indebted to the many people who have helped me. I particularly thank Mr Leslie Worth, the distinguished watercolourist, who read an early version of the book and gave me much encouragement. I also thank Mrs Dunbar-Marshall, my sister-in-law, for her practical advice. I am indebted to the British Library for the use of their resources and to the Print Room of the British Museum for the use of their wonderful collection of prints, drawings and watercolours. I also wish to thank the staff of the Print Room of the Victoria and Albert Museum, and in particular Mr Michael Kauffmann for his kindness in reading the book and making useful suggestions. I also thank the Tate Gallery for the use of their resources and for their tireless pursuit of drawings which I could not find. I am also deeply grateful to Mrs Jane Roberts of the Royal Library at Windsor for her guidance in regard to paintings by the Royal Family and especially for her own researches and knowledge of the artistic activities of George III. I thank Mr Michael Spender and Mrs Lynne Williams of the Bankside Gallery for all their help.

I am particularly grateful to all those who have made the paintings of their ancestors available for inclusion in this book. I express my special appreciation to His Royal Highness the Prince of Wales for allowing me to reproduce one of his own watercolours. Last but not least I thank my wife for all the encouragement that she has given me in my interest in the visual arts.

TO VICTORIA

FOREWORD

The purpose of this sensible and perceptive book is set out almost in its first sentence. 'This book,' the author writes, 'is not about how to paint but about how to enjoy painting.' Immediately we recognize that what we are about to read is not one of those 'how-to' books – picked up with a natural and touching wish to be better than we are at something, only to be abandoned half-read. The author starts where we do – as an amateur. Somebody who paints because he wants to and because he enjoys the process, and, above all, because he wants us to follow him, to join him – or even to go ahead of him – along the pleasurable, if occasionally frustrating, path towards self-fulfilment.

He does not pretend it's easy. Watercolours, we know, have traditionally been regarded – absurdly enough – as a minor art fit only for wet afternoons and the physically weedy. (Just read what Edward Lear endured!) But we quickly learn it can be harder than oil painting. Lord Thorneycroft reminds us that the basic discipline, drawing, can only be learned by *doing* it, and is the essential foundation of practising the visual arts.

He advises us about history, about collecting, about learning from the masters, about techniques and materials, about the educational value – now almost forgotten – of copying the work of painters you admire. He knows that in this fleeting and delicious medium you must learn not just to observe . . . you have rather to watch. Above all you must keep your nerve. We all learned to draw as children – excitedly and without hesitation – and soon became self-conscious. The co-ordination of head and hand, we discovered, is no more complex than driving a car, but there is one more vital ingredient to use and cherish – the heart. Only when all three are united in the creative process can we approach success.

What then do we need in addition to these useful and friendly pages – everyone of which is a door into common sense? An alert eye that misses nothing, for 'I see' means 'I understand'; patience with initial clumsiness; a slow accumulation of knowledge and experience; dexterity without slick-

ness; courage; determination. It's a formidable list. But top of them all I would place that quality which we all possess, the power to love – landscape, architecture, nature, the human form – and the wish to share that love with others.

<div align="right">Sir Hugh Casson</div>

1985

The Amateur

*Society always has a destructive influence upon an artist. First by its sympathy
with his meanest powers; secondly, by its chilling want of understanding of his
greatest; and thirdly by its vain occupation of his time and thoughts. Of course a
painter of men must be among men, but it ought to be as a watcher not as a
companion.*[1]

<div align="right">JOHN RUSKIN</div>

An amateur – one who cultivates something as a pastime. The word is used
almost as a term of derision, yet to be an amateur is a delightful thing. In
youth it can open up a new horizon; in middle age it can provide a man,
embattled amid the stress and strain of his main career, with a haven of
peace and relaxation; in old age instead of boredom he can find the
opportunity for which he has always longed – to explore his chosen pastime
in rather greater depth.

My own pastime, in company with thousands of other men, women and
children in this country, has been to paint.

Though I pass on some lessons that I have learnt, this book is not
primarily about how to paint. It is about how to enjoy painting. I assume
that the reader either has some knowledge of the basic procedures or is
willing, through either books or teachers, to find out. This is, then, a book
about amateurs by an amateur.

I myself would take an amateur to be any man or woman who finds the
majority of his or her time occupied by matters other than painting. A
mother of young children, a politician, a lawyer or doctor, or a worker in a
factory, may paint, but would not regard themselves as professional
painters. We are essentially spare-time painters. We paint on holiday, or at
weekends, or at night. The term has nothing to do with whether one
exhibits one's paintings or sells them or what kind of pictures one paints –
least of all what anybody thinks of them. We paint not to earn a living but
to enjoy ourselves. We paint for pleasure.

There are, I recognize, snags about this definition. There are some
professional architects or artists who paint watercolours like the amateurs
as a pastime, and paint them very well. There have been and probably still
are some amateurs who devote so large a part of their time to painting that
it can be said to be their main occupation. The truth is that the dividing line
can at times be a narrow one.

In the early part of the nineteenth century there were quite a number of
amateurs who might in our day have graduated to the ranks of the

professionals. At that time, however, it was not quite the done thing for gentlemen to sell their paintings and they remained amateurs – distinguished amateurs!

Educated people of this period were in any event taught to draw and frequently made drawings from nature. It was the equivalent of photography today.

The sequence of events was often for a man to learn to draw, later to become a patron of the arts, then with growing interest to become a pupil of the artist, and finally in some cases to graduate as an amateur painter himself. This situation provided a highly satisfactory state of affairs for many artists, who found themselves engaged sometimes as painters of scenes chosen by their patrons either inside or outside this country, and sometimes as teachers of their patron's family. Edward Lear, invited by Lord Derby to make paintings in his zoo, spent many happy months with the Stanley family at Knowsley. Indeed it is recorded that Lord Derby, noticing that his grandchildren appeared to have been completely absent for some weeks, enquired as to their whereabouts. He was informed that they now spent nearly all their time with the new artist looking at his drawings and delighting in the rhymes which he composed as an accompaniment to them. Who could blame them!

At the end of the eighteenth century a certain Dr Monro, at one time principal physician at Bethlehem Hospital and himself an enthusiastic amateur painter and collector of paintings, established a kind of academy at his home. He invited young painters to study his collection as well as drawing and painting pictures. It is recorded that in December 1798 Girtin was drawing outlines and Turner was washing in the effects and being paid three shillings and sixpence for his pains. Many famous artists of the period – Paul Sandby, J. S. Cotman, John and Cornelius Varley, Peter de Wint, and many others – joined in the work and practice of this remarkable informal academy.

Few men, perhaps, made such a large contribution to the art of watercolour painting of his day as Dr Monro, but there are endless examples of men who were amateurs linked with the professionals of the day as patrons, pupils and collectors. The amateur and the professional developed and still maintain a mutually supportive role. As I shall show later, I owe much to the professionals who have encouraged and taught me.

For my part I am an amateur whose life-style has fallen far short of Ruskin's advice to be simply an observer of the scene. I have indeed been a companion with others in the heat and dust of public affairs. Nor would I have wished it otherwise. Painting has been to me, as it is to other amateurs, an important part but only a part of life.

And yet that part of our lives which we devote to our pastimes is not

without its effect on everything we do. I recall as a young and newly appointed President of the Board of Trade carrying out a ministerial engagement in Glasgow. I travelled north with my staff and despite their impeccable briefing I sensed a certain anxiety that evening as to how I might perform at the rather critical press conference the following morning. For my part I took advantage of the overnight stay to visit the famous Glasgow Art Gallery which was displaying in addition to its other treasures the newly acquired *Crucifixion* by Salvador Dali. This remarkable painting depicts the figure of Christ upon a cross which leans dramatically forward so that it seems almost to leave the frame as it looms above the head of the viewer. Many of the citizens of Glasgow had joined me to view this new and controversial acquisition.

The press conference next morning was well attended and I could feel that my civil servants still retained a certain tense anxiety as to its outcome. I was, after all, at that time a pretty raw recruit to this level of political activity. What would be the first question? The lack of investment; rising unemployment; foreign imports – there was plenty of scope for trouble. The *Glasgow Herald* opened the bowling. Was the minister aware that the Glasgow City Council had just spent a very large sum of money on buying a most controversial painting by a painter called Dali? Did I think it a good investment? I told them that I could not answer for it as an investment but that it would certainly be judged as among the most important contributions to religious painting of this century and that it had been a privilege to join with so many other of their citizens in their famous Art Gallery to see it. I could just hear the sigh of relief from behind me – a minister so plainly on top of the first question unbriefed was not likely to slip badly on the others. They were right. Always in the years that followed, wherever I was sent – New York, Washington, Brussels, Paris, Geneva, Moscow, Sydney, Melbourne – I looked at paintings. I encouraged, without any difficulty, my civil servants to do the same, spending one extra night if necessary for the purpose.

To travel the world arguing and negotiating in rooms with people who are much the same in one place as another, is to miss great opportunities. I have been fortunate to travel widely and even more fortunate to have seized the opportunity to pause a little from time to time and to see something at least of the beauties of the world. If a man is to understand other men he should at least look upon the things that move them.

An amateur may never paint as well as he would wish, but in his attempts to paint he will learn enough to appreciate with a new vision the great paintings which are available for him to see. Nor need one travel the world to see them, for this country is full of fascinating collections of great paintings. The greatest gift that a painter or a traveller can develop is to learn to look.

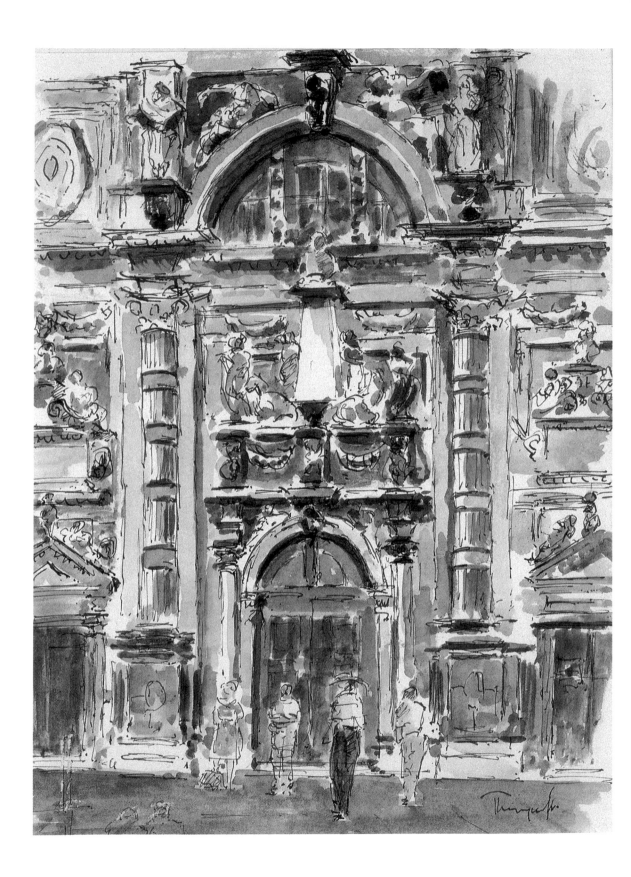

And, of course, we amateurs paint, sometimes well, sometimes less well. But always, I hope, with full enjoyment.

The paintings which we produce are naturally of some importance to ourselves. Often, however, a painting also brings vividly to mind not only the time and place in which it was painted but the surrounding circumstances as well. Our paintings are a sort of diary of our lives. I painted the façade of S. Moise (2) one long, happy summer day in Venice. I sat where the gondoliers await the tourist. The gondoliers often sing as they float upon the lagoon or pass along the canals of Venice, well-known Italian songs such as 'O Sole Mio'. As I was painting, one gondolier much interested in my work told me he was married to a Scottish wife and showed me his photograph in full Highland dress. He had learnt and now regales his passengers with the strains of 'Glasgow belongs to me'. I gather it goes like a bomb, not least with the Scottish tourists. Posterity will not remember my painting of S. Moise but I shall remember my gondolier!

An amateur painter will indeed find a wide circle of friends and acquire some fascinating bits of information while upon his travels. Children squat down beside him and talk with a freedom denied to most adults. Greek farmers will press grapes into his hands or invite him to fill his painting bag with figs. An amateur who paints enters a new world with easier relationships and simpler values than he has perhaps known for a long time.

If, however, we are to enjoy that part of life, it is essential that we develop as much expertise as we can; this, really, for two reasons. It adds greatly to the pleasure of doing anything if one can do it reasonably well. But also in the case of painting the actual attempt to learn something, which one wants in any event to do, ensures many happy hours, often in most congenial company, and generally at little cost. To travel is just as pleasant as to arrive. I still spend rewarding hours at art school and would advise any other amateur who can contrive to do so to do the same.

I must admit that in general we amateurs lack that selfless devotion to the art which is demanded of the professional. Ruskin, that penetrating, perverse and most poetical of critics, compares the ordinary good man who 'spends his summer evenings on his own lawn, listening to the blackbirds or singing hymns with his children' to the life demanded of a painter.

> You can't learn to paint of blackbirds, nor by singing hymns; you must be in the wildness of the midnight mask, in the misery of the dark street at dawn. . . . Does a man get drunk, you must be ready to pledge him. Is he preparing to cut purses, you must go to Gadshill with him. Does a man die at your feet, your business is not to help him, but to note the colour of his lips. . . .[2]

We amateurs do and probably should fall rather short of all this in our enthusiasm for the art. Nevertheless we should follow Ruskin's advice at least to the extent of looking with a new awareness at the world about us.

2 *S. Moise*,
LORD THORNEYCROFT
A sort of diary of our lives

Though I shall be tempted to tell you how I try to paint myself, the purpose of the book is not really to teach you how to paint. It is to tell you how to enjoy paintings, where to find them, what to look for in them. It is a book for amateurs – for those who love painting. If in what I say about the art and about the professionals and amateurs who have practised it, I encourage you in your own painting or perhaps simply to start painting, so much the better. As the American essayist Ralph Waldo Emerson said 150 years ago, 'skill to do comes from doing'.

Watercolour

The extended practice of watercolour painting, as a separate skill, is in every way harmful to the arts; its pleasant slightness and plausible dexterity divert the genius of the painter from its proper aims, and withdraw the attention of the public from excellence of higher claim. . .[1]

JOHN RUSKIN

The medium I now use almost exclusively is watercolour. Though in many ways it is the most difficult medium to handle, thousands of other amateurs have chosen it as well. It is no part of my purpose, however, to argue exclusively for watercolour as opposed to other methods, or against other methods combined with watercolour.

An amateur is indeed well advised to try everything. Experiment – choose later what suits one best. If one seems to be in a rut in painting by one method, change the medium. Try sharpening a stick, putting it in indelible ink and drawing with that. Wet a brush and draw the ink into the shadows. There are wonderful possibilities in all media and much also of advantage to be found in mixing them. Just try them out.

I have, I think, chosen watercolour for myself mostly for the exceptional beauty that I find in the glow of the paper shining through the transparent washes of the colour. It is apt for the quick impression of a transitory scene. It is capable of everything from a passing note to a beautiful and highly finished work. There is a revealing passage in Evelyn Waugh's *Brideshead Revisited*. Charles Ryder has broken the news to his father that he intends to leave Oxford and take up painting as a career. 'I'm not', says his father, 'going to have you painting in the gallery nor will I have undraped models all over the house . . . and I don't like the smell of turpentine. I presume you intend to do the thing thoroughly and use oil paints.' Charles Ryder recalls that his father belonged to a generation which divided painters into the serious and the amateur, according as they used oil or water.

This passage accurately reflects a widely held attitude that watercolour is somehow a second best, fit only for a man or woman playing at painting rather than engaged upon that earnest searching after truth and portrayal of the beauties and contrasts of the world which should be the true aim of the visual arts.

The best answer to this is perhaps contained in an introduction to the catalogue of paintings lovingly collected by Claude Monet and exhibited at the Musée Marmottan in Paris.

Do not let us be under any illusion. Despite the apparent simplicity of the technique which requires the very lightest and least cumbersome of materials, watercolour is not an art for a beginner. It requires a precision of eye, a sureness of hand, a virtually daily practice of washes, and above all a speed of execution of which only the greatest artists are capable.

The collection contains watercolours by Boudin, Jongkind, Berthe Morisot, Signac and others which speak for themselves. If ever in Paris, do not miss it.

And don't be put off by the fact that painting in watercolour is difficult. If a pastime is to bring that feeling of relaxation from the pressure of the problems which crowd in upon us in our daily lives, it must above all be difficult. It must present a real challenge; each even partial success must open up yet one more horizon which we can strive towards. We are, after all, not trying to develop a habit but taking part in an adventure. Success in the perfect pastime should never finally be achieved.

The use of water as a medium for painting dates back to far distant times. It was used by the Chinese to put paint on rice paper and by the Egyptians to paint papyrus. It was used in Europe in the Middle Ages in the painting of mediaeval manuscripts. Brilliant and beautiful calendars like 'Les Très Riches Heures du Duc de Berri', painted in the early years of the fifteenth century by three young brothers who all died of plague by the age of thirty, bear witness to the skills of those who preceded the painters of our own day.

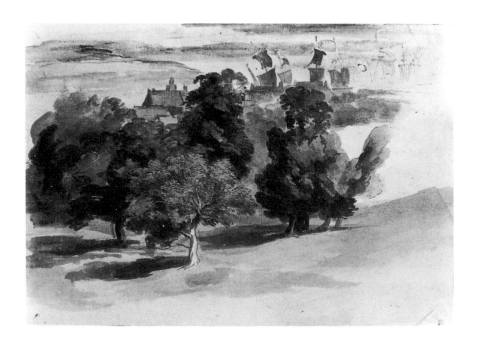

3 *Landscape*, A. VAN DYCK
The influence of Holland

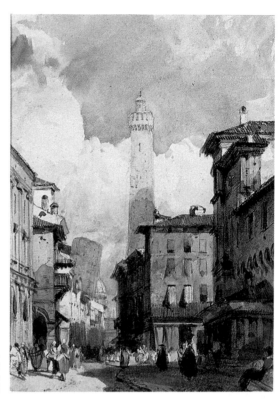

4 *The Leaning Towers, Bologna*,
R.P. BONINGTON
A master of whatever technique he
adopted

5 *A Lady at her Toilet*,
R.P. BONINGTON
A technique verging upon oil

Watercolour painting in anything like the form in which we know it was
not really found much before about 1500. Let a painting by that accom-
plished and sophisticated Court painter Anthony Van Dyck both speak for
these pioneers and bear witness to the influence which the Netherlands
brought to the art of the British Isles around this period. When Van Dyck
painted this picture (3) he faced much greater technical problems than you
and I face today. The pigments were bought from apothecaries' shops and
generally ground and mixed with gum arabic by apprentices. The resultant
rough dry lumps were ground again and mixed with water before applica-
tion of this, by our standards, rather crude paint. It was with these
techniques that early amateurs painted the ink and colour tinted early
landscapes of their day.

The amateur painter really came into his own when William Reeve hit
on the idea of mixing the gum arabic and paint with honey around 1780,
and received a further bonus about 1830 when Mr Newton and Mr Winsor
incorporated glycerine to form what is more or less the modern moist
colour paint and put it into the kind of tubes which are sold today.

From this point it was really downhill all the way. The new materials lay
ready to the hand of the great watercolourists of the period and they made
full use of them.

There are, of course, many ways of using water as a medium. Paint can
be mixed with white body-colour as in gouache to provide an opaque
medium and a technique verging towards oil painting; pastel or white
body-colour can be superimposed on ordinary watercolour. Watercolour
can be painted over a ground of white body-colour.

Richard Bonington (1802–1828), one of the most accomplished though
tragically short-lived painters in an age when the art of watercolour was at its
peak, used more than one technique (4, 5). He was plainly a master of
whatever method he adopted. The Wallace Collection in London has a
collection of his work in these various styles which is well worth a visit.

Some watercolourists sometimes regard these other aids rather in the
way that a dry fly fisherman would react to a proposal to use a worm or a
spinner to catch trout. We need not be such purists. By all means try them
all. For my part I have developed an attachment to pure transparent
watercolour, leaving the paper for the highlights. Try that, too.

England is famous in the world of art for her watercolourists, this
perhaps for a variety of reasons, not least for her climate, for her softly
coloured landscapes and misty distances, for the broad sweep of her skies,
for the multitude of colours in her clouds, for her sunshine and her deeply
tinted shadows.

I once had the privilege of being taught at least the elements of drawing
by Vivian Pitchforth. He was a fascinating and gifted Yorkshireman,
unfortunately completely deaf; a brilliant draughtsman and famous water-

colourist. His paintings were widely admired and eagerly bought each year at the Royal Academy Summer Exhibition. When Vivian said it had been a lovely summer he meant that it had poured with rain with storms sweeping in across some beloved estuary to create the coloured shadows on the wet sands which his brush could capture with such mastery (7).

One of the advantages of painting as a pastime is that one can really paint anything, at any time, anywhere, and this is particularly true of watercolour. In rain or sunshine, countryside or city, indoors or out, an endless range of opportunities presents itself.

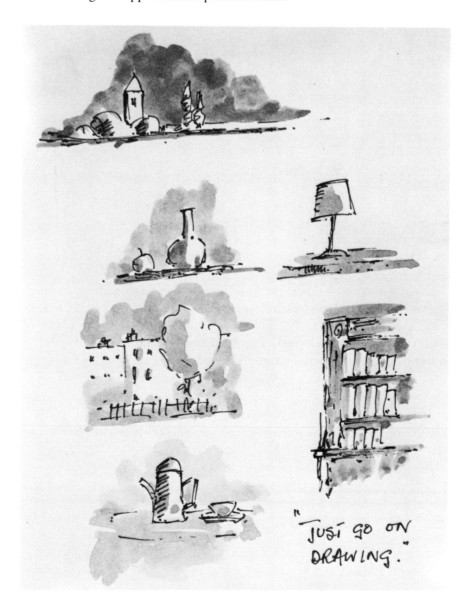

6 *Sketches*,
LORD THORNEYCROFT
Just draw and go on drawing

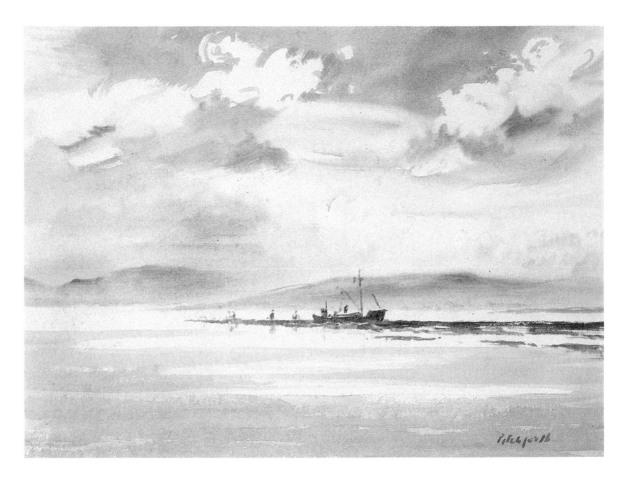

7 *The Estuary*, VIVIAN PITCHFORTH
Softly coloured landscapes and misty distances

Watercolour is above all a technique which invites the painter to react to the immediate and passing scene. It can, of course, be used for more deliberate and posed situations but is perhaps at its best when painted under pressure of the events portrayed. The only way to understand it is to start to paint with it.

How then does one start to paint? Some readers of this book no doubt already paint but there are others who wonder how you set about the business. This is a book for beginners.

I started more or less by accident. In the summer of 1951 I was on holiday in Brittany with my wife and four children ranging from a stepson then aged fourteen down to our daughter Victoria who had only been born that June. It rained as it often does in that north-western, misty, beautiful area of France. My wife took herself off to Lannion to buy watercolours

Isola S. Giorgio fram
Anna Maria's window —

8 *Venetian Sketch*, LORD THORNEYCROFT

and we embarked on an intensive portrayal of the local scenery. We had exhibitions in our rooms each evening and, as in the modern system, prizes were awarded to all. It was to be the first of many painting holidays which I was to enjoy. Did I but know it, those first rather clumsy attempts at drawing and watercolour were to trigger an interest which would drive me to spend many hours in mastering the art and occupy great stretches of any spare time that I was to have in the years to come. All my family remember that holiday. What fun we had and how laughter echoes down the years! I remember that hotel if only from the fact that it cost only £1 per head per day full pension. This must say much either for my present age or for the progress of inflation in Northern Europe or both. It was, in any event, a holiday enjoyed by all. When we left, the proprietor enquired whether he could have a painting, not, he explained, necessarily by the master, but by

one of the others. As we were turning out paintings in a quantity, though not perhaps of the quality, of an Italian Renaissance workshop there was no difficulty in this. In years to come, if any art historian, researching in that area, comes across a painting of La Chapelle de la Bonne Nouvelle rather weakly drawn, he should therefore attribute it to one of the younger artists, though not to the youngest and later the best watercolourist, who was, of course, still in her cradle.

That holiday was then to launch me on a life of painting but it was also in some ways the last of the summer wine. We returned to England to a general election in which I held Monmouth for the Conservatives and, a few days later, Winston Churchill sent for me. I expected perhaps to be given my old job of Parliamentary Secretary to the Ministry of Transport or possibly, just possibly, to become the Minister in that Department. 'I want you,' said Winston, 'to be President of the Board of Trade and a Member of the Cabinet.' I obviously looked a little pale. To tell the truth, I hadn't thought that there was even the wildest possibility of being offered a job in the Cabinet. Winston leant forward to encourage me. 'You will find it', he said, 'the most charming house.' He was actually thinking of the old Board of Trade which he had inhabited a generation earlier, but no matter. I recovered sufficiently to express my thanks for this advancement. I left, a Cabinet Minister at forty-two, to embark upon a long career in high office.

There is, I think, encouragement to be found for all amateurs in these events. It is possible to become quite an adequate painter from quite small beginnings with a child's paintbox. It is possible to start as late as forty-two and many start much later. It is possible to embark on painting no matter how challenging and enthralling one's main career may be.

To anyone starting now I would, however, advise rather simpler subjects than church architecture. The important thing is to take one's courage in both hands and make a start. What is needed for a beginner is minimal.

You buy, beg or borrow:

1. A sketchbook which will fit your pocket, 6″ × 8″. Any art store has these, generally in black covers.

2. A Biro indelible pen from any stationer. (Later, you will try more sophisticated pens, but this does well for a start.)

3. A small brush, No. 6 or 7. Get a good-quality one, but you need not at this stage buy a sable one as they are expensive.

4. A cake or tube of paint of some neutral colour. Brown, black or Paynes Grey will do.

5. A small container for water, such as the bottom half of a plastic soap container.

6. A small dish or saucer on which to mix the wet paint.

Having so equipped yourself, you open the book and draw anything you like, however badly. You draw from what you see – or can think of – or

from a book – or copy a photograph or another painting. You wet the brush, dissolve a little paint and shade the parts which you believe to be darker than the rest. Ink and a wash, as it is called, of this kind looks lovely anyway on paper. At this stage the accuracy of the shapes doesn't matter – just draw and go on drawing (**6**). Forget about pencils and rubbers and whether the lines are in the right place – if you don't like one line, draw another (**9**). Later you will paint in colour, but think always as you are thinking now in light and shade and you will become a painter. Try to draw something, however small and simple, every day. Above all, start to look closely at paintings done by other people.

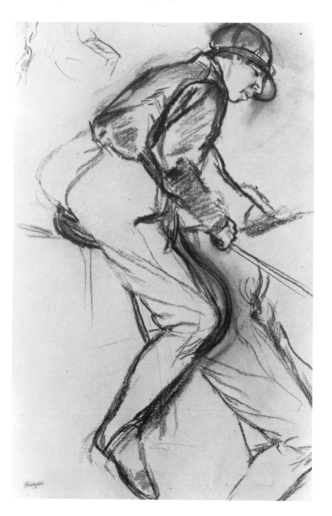

9 *The Jockey*, EDGAR DEGAS
If you don't like one line draw another

Learning

His own talent, if you can help him find it, is the most precious gift that you can make to a student.[1]

<div align="right">WALTER SICKERT</div>

There are, I think, three things necessary to make a good painter. He must love it, he must look closely at the paintings done by others and he must learn all he can about it.

I have discovered that the higher one rises in the world, the easier it is to contrive the time to learn to paint. My life lay along paths far removed from the painting class. I remember as a minister newly arrived in a government department telling my staff that they well knew that all ministers had their vices, and mine was to draw in the Life Class at the Chelsea School of Art between 6 p.m. and 9 p.m. on Tuesdays and Thursdays. Of course, I didn't always manage it, but the Civil Service is a highly civilized society with a keen appreciation of what matters in a man's life, and I was able to attend more often than one might expect.

I recognize that a busy housewife may well find it harder to spare the time. Children, husband, household cares can often be more urgently demanding and nearly always less movable in time than the tasks of a Secretary of State. Nevertheless the benefits of some professional tuition are immense. I personally owe a deep debt of gratitude to those devoted teachers who have been prepared over the years to guide, encourage and correct me. I am at least doubtful whether I would advise a middle-aged amateur to take a full foundation course at an art school even if he could spare the time. A thorough grounding in all aspects of the business is of course useful for anyone setting out on a professional career. But an amateur is not setting out on a career as a painter. He has simply determined to enjoy himself and there really is quite a difference between the two approaches. There is also a certain danger in too much tuition. We all have some gift for what we do, a sort of handwriting. It may often be hard to see but sooner or later it will come out in the pictures that we paint. There is, at least in my judgement, a danger that a real blockbuster approach to art training may eradicate even the small gifts that we do possess in exchange for a rather general run-of-the-mill technique which, though it may be competent, is often rather dull. We don't all want either to speak or paint with a kind of Oxbridge (or Chelsea/Camberwell) accent.

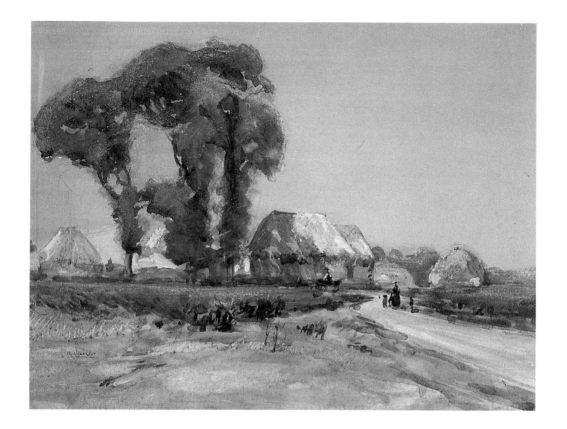

10 *The Elm Tress, Kirby Road, Nr Frinton, Essex*, ROBERT ALEXANDER
Influenced by Brabazon (see page 117)

In practice, I have noticed that the best teachers are very careful to adopt a non-dogmatic line with students. The quotation at the beginning of this chapter really has a lot of truth in it. The art of teaching is to draw out such gifts as a student may possess.

To paint with any kind of freedom one needs to study and above all one needs to draw. The process through which one can obtain instruction is extremely simple. One does not have to walk up the steps of some well-known art school and demand admission. One simply goes to the public library. Many people don't realize the important role that the public libraries play in the social life of this country. They have a fund of invaluable information about the life that is going on around them and about the societies and associations which exist to further it. You enter the library and go to the information desk. The same one you go to when you can't find a book. You ask for information about drawing lessons. They produce a guide book which contains all the things that are taught locally to adults, from cooking lessons to the construction of stained glass windows.

If, like me, when faced with an enormous range of choices you are a bit slow, they help you find what you want. You want to paint watercolours, so don't go to the classes on painting and decorating, important and valuable though these no doubt are. Look under Art. Put aside for the time being a series of lectures on Art History or Art Criticism – save these for the future. Select drawing or painting classes – evening ones if you find these more convenient. Ask for the literature of the school which you prefer. The library will have it for you. Study the cost of the classes. If it seems high, look for another class. Fees are generally quoted as so much a session of a number of specified weeks at so many hours attendance.

In general, tuition is, considering the high quality of the teachers, quite remarkably cheap. Some of it is, of course, state or rate aided. When you go to the school you will probably find facilities for the cheap purchase of equipment, but take along a board, some drawing pins, a pencil and paper and a small box of watercolours. You will find yourself embarked upon a delightful pastime.

If you paint it is pleasant to meet other painters, and through such schools or through the public library system you will come into contact with art societies where quite a number of interesting events take place, sometimes including demonstrations. You will also find opportunities to exhibit your work either in students' exhibitions at your school or in public exhibitions outside.

Painting is, after all, a means of communication. It records a kind of vision that one person has of something and seeks to transmit to another. My son is an architect and when at school used to draw in ink and wash a long series of strange, beautiful baroque buildings. Just who should live in the impressive towers, courtyards, terraces, and so forth was not defined. They were for him a kind of dream world and he sought to record it for himself. It was his drawing master who suggested that others might be interested to see these drawings and that they could be pinned up for exhibition. My son at first regarded this idea with surprise – almost with awe. He had thought of his paintings as a means of communicating with himself and not with others. He accepted the suggestion, however, and began the process of communicating ideas with a pencil – which in his work he, of course, does very well today.

Many private colleges and institutions offer tuition. I personally attend one of the oldest of these colleges, the Heatherley, now under the direction of John Walters, himself a skilled portrait painter. Painting in its open studio and endeavouring to portray the models there, provided with assistance from very skilled professional staff, certainly concentrates the mind. This school has an admirable facility of selling attendance tickets which can be used at one's convenience. A kind of pay-as-you-paint technique, useful for those much occupied with outside interests.

Some of these schools are, of course, very famous; some are really restricted to whole-time students seeking a professional career. Many have fascinating histories and a proud list of painters whom they have trained.

Perhaps the most famous is the Slade School, which opened at University College in 1871 under the first of a series of notable professors, Sir Edward Poynter. It includes both graduate and postgraduate groups of about the same size. Whatever the influence exercised through its teaching, its students certainly represent a brilliant cross-section of the changing pattern of the Fine Arts since its foundation. Though primarily for professionals, it has trained such accomplished amateurs as Robert Alexander (**10**), mentioned again later in this book, and importantly its traditions have been transmitted to thousands of amateurs through a whole series of Slade-trained artists and instructors.

Suppose, however, that one simply cannot find the time or opportunity for professional assistance of this kind. Even then the help that can be found in books is indeed considerable. Hardly a branch of painting, including particularly watercolour painting, is without a specialist book dealing with almost every aspect of the work. How to draw, how to lay on a wash, how to stretch the paper, how to put the paint on, how to scrape it off. You name it; they write about it. For convenience a by no means exclusive list of books which are helpful is included in the Bibliography.

One or two words of warning. Don't expect to find in books of instruction the sort of paintings that you would wish to paint. The exercises demonstrated, fascinating though they may be, don't normally end up in masterpieces. Be cautious to start with about complicated techniques. The tricks which are shown may prove useful and can be used in some degree, but are not, I think, much to be encouraged in beginners and often look rather obvious in the finished work.

Teaching, at least from books, tends therefore to be exclusively about techniques. They are invaluable, but to be technically very good is not of itself to be a good painter. The best teacher of all is, perhaps, the work of the masters.

One of the gifts given to the amateur is that he does know at least something of the difficulties of the art and has learnt in some degree to look at the world about him with sharper eyes than most. These gifts can be very usefully enjoyed by visiting galleries or looking at the brilliant reproductions of great paintings in books – available in the public libraries.

The late Tom Keating, whose paintings were rather too frequently mistaken for Samuel Palmers for comfort, provided an embarrassment to the art establishment but also produced some lessons for the rest of us. Asked in a rather moving television interview, shown on screen a short time after his death, what his own style was, he thought long and hard. 'I can draw a bit,' he said, in a rather obvious understatement. He was, he

thought, 'a romantic'. The fact is that after a hard practical training as a house painter, and a stint at the Goldsmiths' College, he had really learnt his trade from books and paintings. He looked so hard at other people's brush strokes that he learnt how to do them himself.

Now do not misunderstand me. I do not advise the amateur to attempt to fake Constables, but there really is more to be learned by close study of the works of other artists than by most other methods. Great artists themselves learn from one another. Japanese prints, for example, have made a deep impression upon many English painters.

Tom Keating's TV talks on other painters and his demonstrations as to how to set about such pictures are certainly effective education. The basic things which these painters did in tackling the complex problems which they set themselves in the masterpieces which they created are the same basic things that we amateurs all have to do in the simpler and less ambitious problems which we should try to set ourselves.

One thing is for sure. Television and perhaps even more the video cassette will increasingly become an instrument of education in a whole variety of occupations. It is, for example, already widely used in teaching surgery. In painting it will bring to us amateurs wherever we live the help that only a minority of us can get in practical demonstrations today. Imagine what it would be like if it had been possible to catch on tape the creation of such a miracle as the painting of a watercolour of Mont S. Victoire by Cézanne. We are at the beginning of a new era in all forms of art education.

To return, however, for a moment to Tom Keating and the question of a style in painting – an individual handwriting. It is possible, even probable, that Tom Keating did not have a painting language of his own or perhaps lacked the resources or the time to find one. Most amateurs are not so disadvantaged. A marked individual style will be none the worse if it has been influenced by study of the actual paintings done by the best of the professionals. I will relate, however, a cautionary tale.

Some twenty years ago I was persuaded by Lord Mountbatten, with whom I was then serving in the Ministry of Defence, to exhibit some of my drawings and paintings in aid of the King George V Fund for Sailors. The exhibition was held at Chichester and the *Daily Express* newspaper, perhaps short of any more exciting copy, took an interest in the event. It had the bright idea of photographing three of my drawings and asking the directors of three well-known London galleries what they thought of them, without, of course, saying who had painted them. Rather like one of those wine tasting parties with a bottle of plonk thrown in to fox the connoisseurs. The results appeared as illustrated (**11**).

Perhaps, then, there is more of Tom Keating in me than I would care to admit. Yet if anyone bought a drawing that had something of Cézanne, etc.

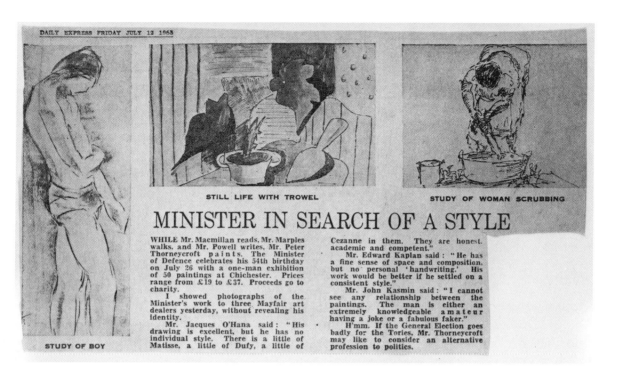

DAILY EXPRESS FRIDAY JULY 12 1963

STILL LIFE WITH TROWEL

STUDY OF WOMAN SCRUBBING

MINISTER IN SEARCH OF A STYLE

WHILE Mr. Macmillan reads, Mr. Marples walks, and Mr. Powell writes, Mr. Peter Thorneycroft paints. The Minister of Defence celebrates his 54th birthday on July 26 with a one-man exhibition of 50 paintings at Chichester. Prices range from £19 to £37. Proceeds go to charity.

I showed photographs of the Minister's work to three Mayfair art dealers yesterday, without revealing his identity.

Mr. Jacques O'Hana said: "His drawing is excellent, but he has no individual style. There is a little of Matisse, a little of Dufy, a little of Cezanne in them. They are honest, academic and competent."

Mr. Edward Kaplan said: "He has a fine sense of space and composition, but no personal 'handwriting.' His work would be better if he settled on a consistent style."

Mr. John Kasmin said: "I cannot see any relationship between the paintings. The man is either an extremely knowledgeable amateur having a joke or a fabulous faker."

H'mm. If the General Election goes badly for the Tories, Mr. Thorneycroft may like to consider an alternative profession to politics.

STUDY OF BOY

11 *Minister in Search of a Style*

in it for between £19 and £37, it does not seem to me that they made too bad a bargain. The distinguished directors of the art galleries were, of course, right: one should develop an individual style. I can, however, assure you that many a professional has mirrored other painters on his way to developing a recognizable style of his own.

To summarize this question of learning, one should seek all the professional assistance that one can. Such proficiency as I possess, I owe to many hours spent in art classes, patiently striving to get it right. One can learn to draw. The mere constancy of the attempt gradually improves things. Some people have a natural gift for drawing. I am not among them. Like most others, I have had to learn the hard way. I am now reasonably good, and drawing is a good foundation for painting.

Whether you actually learn to *paint* in an art class is perhaps to some degree a matter of luck. Most classes are concerned with drawing and with oil painting. Very few with actual painting in watercolour. In truth, painting in watercolour is such an individual thing that it is not easy for a person to teach other people without imposing his own eccentricities upon them. A combination of art class, books on painting, practice and above all studying the work of other artists seems to be the best procedure to advise.

Drawing as a Means

Only remember this that there is no general way of drawing anything, no recipe can be given you for so much as the drawing of a cluster of grass.[1]

JOHN RUSKIN

Most of us may never match the skills of the masters. We can, however, learn much from them, and even more if we seek to master at least the basic language of the art. The basis of the art is drawing. It is not the whole of it by any means, but it is the foundation upon which other things can be established. Every amateur should seek constantly to improve his drawing. A great draughtsman may in fact only make a few marks upon his paper or his canvas, but those marks provide the structure for his work. Without them a painting will tend to be a weak and feeble thing. So we learn to draw.

Drawing is in a very real sense a kind of visual memory. You look at some object and examine carefully what you see. You drop your eyes to the surface upon which you are drawing and reproduce upon it the shape which you saw. Some artists develop a very acute vision and can hold in their minds what they have seen, sometimes over a long period before they reproduce it upon paper. James Whistler used to get his friend, Walter Greaves, and Walter's brother, both amateur artists, to row him across the river Thames. They would then turn round and with his back to what he had seen Whistler would recall in words the objects he had been memorizing. The tree, the house, the colours, the shapes, while his friends corrected him.

There is a story which well illustrates the manner in which great painters can capture and retain a visual memory of what they see. A young woman found herself travelling northward in a railway carriage of which the only other occupant was an elderly gentleman. A storm was raging outside. The elderly gentleman suddenly rose to his feet, opened the window, put his head out and held it there for some five or six minutes. Eventually he withdrew his head, closed the window, resumed his seat and sat deep in thought for some considerable time. The young woman, fascinated by these activities, herself opened the window, put her head out and gazed upon the swirling rainstorm which enveloped the train as it sped through the countryside. Some months later she was attending with friends the

opening of the Royal Academy Exhibition. A crowd had gathered before J. M. W. Turner's painting, *Rain, Steam and Speed*. 'Magnificent,' someone said, 'but nothing could really look like that.' 'But it could and did,' said the young woman, and she recounted the story of how she had come to have the same visual experience as the man whom she now realized was the famous painter.

The amateur who is neither a Whistler nor a Turner will simply have to do his best.

There are many books on drawing and many rules which we are advised to follow, but there is no real substitute for looking very hard at some quite small area of what we have to draw and then seeking to reproduce it as exactly as we can. It is something which gradually becomes possible to do. I started to learn to draw at the Chelsea.

I remember sitting in the life class, where we were sharpening our pencils and looking rather apprehensively at the curves of the lady sitting patiently, and clearly rather bored, on the couch in front of us. 'You start,' said Vivian Pitchforth in his broad reassuring accent, 'at the stoo-mach and work outwards.' (12)

It was certainly not a bad way to start. There are, of course, other ways of approaching the subject. 'Look,' said the young teacher from the Slade, 'at the negative form between the lady and the chair – draw that first.' Both these approaches are valid and it is in the combination of the two that success in draughtsmanship will lie.

The second method, the art of drawing *by the spaces left*, as advocated by the young teacher from the Slade, is best described by the painter Solomon J. Solomon.[2] He is describing how he drew a white plaster cast of a horse against a dark background (13):

I looked at the cast, my eyes almost closed, and then drew the Space lying between the neck and the jaw, a little island of black, treating the shape of it as I would a free hand drawing. I had by this created my standard of measurement.

Proceeding upon this basis, I did not ask myself yet whether I was drawing a head or legs or a body, because I knew that if I drew the patterns left by the white cast on the background, in proportion with the passage already indicated, my subject would be evolved. My eyes remained always nearly closed. I was reducing the round object to the flat – that is to say to the spaces occupied by its parts on the background.

Observe that Vivian Pitchforth and Solomon J. Solomon have one important thing in common. Neither makes any attempt to block in the whole figure or object, which many of us attempt to do when we first start to draw. Both these very able teachers take one line or one small area and use it as a basis of measurement for all else. Both then proceed from this step by step, measuring with a pencil or pen held at arm's length so that the

drawing is built up by its accurately observed parts. One is concentrating on what happens within the boundaries of the object, the other on what happens outside it. The technique is, however, the same. The amateur is well advised to make use of both approaches.

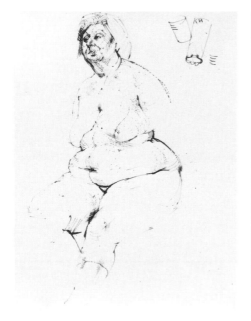

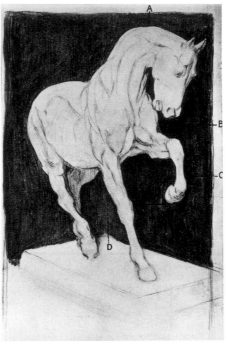

12 *Seated Model*, VIVIAN PITCHFORTH
'Start at the stoo-mach and work outwards'

13 *Plaster Cast*, SOLOMON J. SOLOMON
'I half closed my eyes and drew the patterns on the background'

Let it be admitted that in this manner of drawing, error and inaccuracies accumulate. They are, however, the errors and inaccuracies of things honestly observed, and the total sum of all this work is an honest and interesting appraisal of the whole.

Francis Bacon, I think, understood this when he wrote in his essay on beauty: 'There is no excellent beauty that hath not some strangeness in the proportion.'

Some people draw more easily than others, but nearly everyone can learn to draw in some degree. Much can be learned from books upon the subject. Even more from teachers. Most of all from just practice. Draw at least something every day. Essentially, drawing is a trick between the hand and the eye. Good draughtsmen just see more and react more accurately than the rest of us. The value of good teachers is to tell us what we missed.

One can, and indeed should, learn something about the rules of perspective, but good drawing really has nothing to do with rules at all. It is the art of putting down on paper the truth of what is actually in front of us. We draw better as we look longer and harder at the object or the person or the scene before us.

Drawing in a life class is indeed a good training ground. There is perhaps no more difficult problem than the subtle changes in direction and perspective that are to be found in the human form. You can hear a pin drop in a life drawing class. The whole mind and effort of everyone in the room is concentrated in a supreme effort to achieve that discipline of eye and hand which will translate the form into a line upon the paper.

Many amateurs will find it difficult to arrange to attend a life class. Not to worry. Sickert[3] regarded such classes as a disaster:

It would be interesting to secure medical statistics on the average number of young women students a year whose health has been broken down by excessive hours of drawing from the nude in the exhausted atmosphere of rooms heated to the temperature necessary for the model.

So draw something else but go on drawing. By some strange alchemy, if you try for long enough your drawings begin to resemble the objects which you wish to depict. It is quite exciting when it happens.

Vivian Pitchforth used to make his drawings and demonstrations in a mixture of brown waterproof ink and red chalk. Many were works of art in their own right. Students were in the habit of encouraging him to make corrections and demonstrations on the pieces of paper they were using and then taking them away for framing. The habit grew to a point that compelled us to agree a small charge for 'masterpieces' collected in this way.

A capacity to draw simply and accurately is an immense advantage to a painter. It is a facility which with practice most people can in some degree develop.

I would admit a distinction between the watercolourist and the oil painter in their use of drawing. Clearly all painters differ widely in the manner of their approach, but in general the watercolourist tends to work directly from the subject and to finish his work while still in front of it.

The oil painter is, with some very glorious exceptions, a different case. The normal approach to oil painting is by the sketchbook and the preliminary drawing, often, though not always, squared up for transfer to the canvas. These sketchbooks and squared-up drawings or small watercolour sketches are often very beautiful things in their own right. Every watercolourist should study the sketches of men like Constable and Gainsborough to grasp the way in which the impression of a landscape can be captured almost in shorthand by the skilled use of pencil and of colour.

Sickert's habitual method before he began on a canvas was laborious and painstaking in the extreme. Many careful drawings, sometimes squared down to half a centimetre, annotated and with detailed colour notes of the tiniest points, as well as oil sketches on panel, went into their preparation.

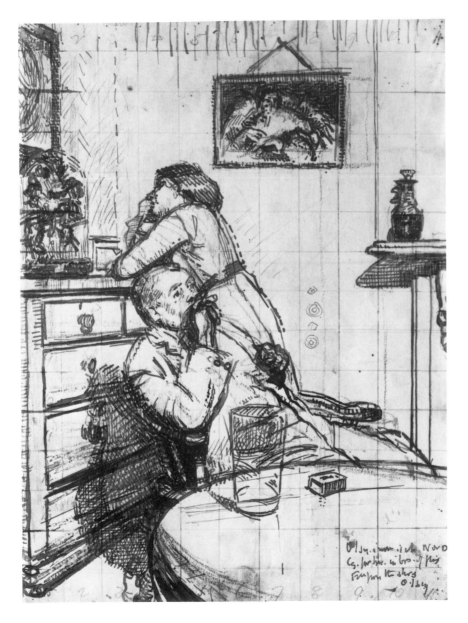

14 *Squared-up drawing for 'Ennui'*, WALTER SICKERT
'Paintings should be made from drawings not from life'

One of the most rewarding aspects of Sickert was that he could write as well as paint. He loved to lecture and to talk, and much, therefore, of what he wrote and said is still available to the student of today:

Paintings should be made from drawings, not from life.

Draw with a hard pencil, the harder the drawing the easier to paint from.

If a student cannot draw his brother, whom he has seen, how shall he draw Ulysses or Ariadne whom he has not seen?

Never rub out, never deny.

Never throw away a drawing. Ten out of a hundred may be good. The others? There is nothing lost. You leave them to your widow.[4]

Sickert was indeed the great advocate of sketching. 'Let those who despise sketching,' he said, 'remember that there are certain tricks, certain beauties, certain swift relations between the thrilled observer and the fleeting beam of light of which sketching, and sketching alone, is the human and intellectual expression.'[5] **(14)**

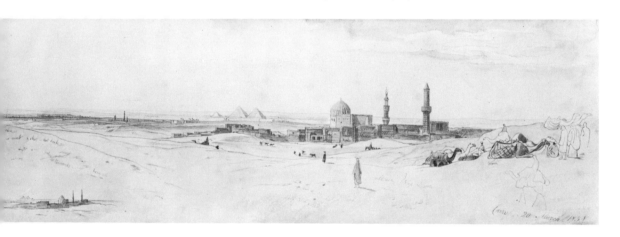

15 *View near Cairo*, EDWARD LEAR
A tiny thumbnail sketch

Edward Lear is the supreme example of the painter who sketched and drew and painted with a view to preparing for later more considered works, generally in oils. Accompanied by one devoted companion, he tramped the world recording landscapes in ink and watercolour, often appending notes referring to the colour, the state of the weather, and the discomfort of the local insects. The finished oils were for long rather disregarded, but the watercolours live and are in great demand. Lear had one other habit which is well worth observing. He often made in ink a tiny thumbnail sketch of the painting he was going to do and happily left it there for us to see **(15)**.

It is in fact easier to decide the balance of a composition if you try it on a small scale for a start. The question you are asking yourself is, will it work? and it saves a lot of time if you can attempt a preliminary answer in a square inch rather than a square foot. It may not be the right answer, but Lear found it worth trying and we may find it worth trying too.

Many other painters filled sketchbooks with their colour notes which the amateur is well advised to study. A Graham Sutherland notebook has been skilfully reproduced in facsimile by the Marlborough Fine Art Gallery. It shows the original preparatory drawings and paintings which he did before squaring them up and developing them into much grander paintings in oil with titles like *Hanging Green Object*.

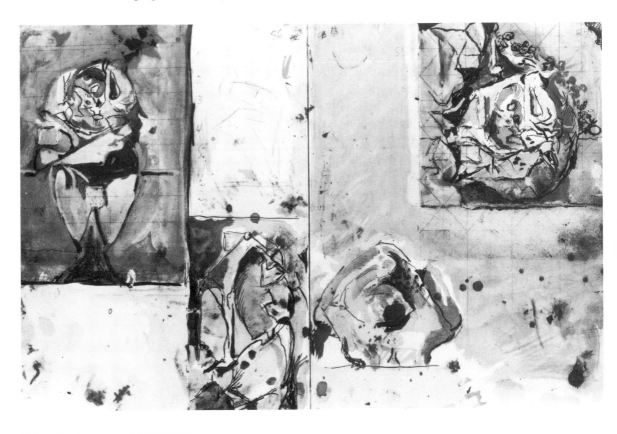

16 *Sketchbook*, GRAHAM SUTHERLAND
The way in which he studied nature

These sketches by one of the most considerable artists of our time give a fascinating insight into the way in which he saw and studied nature and how he abstracted or extracted from it the foundations of his paintings (**16**). I must confess to a no doubt perverse preference for the original water-colours in the sketchbook over the finished work.

Edward Seago, who was a considerable landscape painter, particularly of East Anglia, that great habitat of English landscape painters, once told me how he painted many of his larger pictures. He did the sketches outside and the painting in his studio. But outside he did two sketches, one a rather careful pencil sketch setting out the various points of importance in the scene, the other a quick, free, colour sketch in chalk or watercolour. He said that with practice these watercolour sketches came to a point at which they could stand not merely as colour notes but as paintings in their own right. His watercolour landscapes are indeed a great delight.

So the great men sketch and draw. The amateur, whether he paints in watercolours or in oils, is well advised to do the same. Your sketchbook should be your constant companion. Sketching needs only the lightest of equipment. You require your pocket-sized sketchbook, and pen or pencil. (I would advise a pen. A Biro will serve the purpose, but try a Rotring or one of the fountain pens designed to take indelible ink.) You need the smallest paintbox with a cut-down brush or two, a small plastic bottle for water, half a soap-box to hold it and a few face tissues to mop up. For this a man doesn't need a satchel and a woman can carry it all easily in a capacious handbag. I admit to a weakness for carrying either a shooting stick or one of those light folding stools so that I can select exactly where I want to sit. Remember that Constable and Graham Sutherland carried no more and it is with this minimal equipment that the pleasures of sketching can be experienced. Success or failure with a drawing cease to matter – just turn the page and start again. We are not, after all, attempting great art; we are about the business of enjoying ourselves.

Remember that an artist's notebook is not a tidy thing with a little masterpiece on every page. It's there for practice and for trial and error. The problem for the amateur sketcher is not really the drawing, it's the feeling that you may be chucked out of the restaurant for irritating the other customers.

Drawing and sketching do require a certain tact, as does photography. With experience and confidence, however, one just gets on with it. For the amateur there is a kind of psychological barrier that has to be got over about sitting down to draw in public. It is quite idle to speculate what observers peering over your shoulder think about your work. I finally broke through the barrier when I screwed myself up to sit in the middle of the Piazza San Marco in Venice and start to draw and paint. The crowds are enormous in Venice but artists are regarded really as part of the scenery. After painting for a few weeks there, one would be pointed out by the tourist guides as one of the sights – a rather odd Englishman who was very fond of drawing Venice. Local inhabitants are anyway rather flattered that artists from other parts show an interest in their native city. So get on with the sketching. The day will come when the crowd watching you

painting from the back ask the crowd obstructing the view in front to move away so that you can finish the bottom of the column. You will have arrived. So take courage, use your pen and your small sketchbook and you will be following in the footsteps of the Constables, the Gainsboroughs and the Graham Sutherlands. There are of course some places which are more difficult. One should ask permission before painting in a church or in a museum. It is generally very willingly given.

The Palace of Westminster is one of my haunts. Painting on the line of march along which the tourists are allowed to pass when the House is not sitting is only permitted before 10 a.m. and then only with special permission. This really means breakfast at 7 a.m., on site by 8 a.m. and packing up by 9.45 a.m. These slightly unsocial hours should be matched in the price of any painting sold. Painting in the libraries of the Lords and Commons is a privilege even more closely guarded and granted only rarely and then to established painters. Painting members of either House in their native habitat should be done only with the greatest care. A quick unostentatious ink sketch while writing a letter might just be passed but caution is advised.

The tendency for an amateur is to try to draw too much of the scene in front of him and to try to draw too fast. Select a small area and try to draw that rather slowly and rather well. I personally tend now to use the notebook for drawing rather than painting and restrict myself to using a little wash of the same nature as the ink.

A sketchbook should be kept. It becomes a kind of diary of one's travels. One's own sketchbook plainly never rivals the sketchbook of one of the masters, but every now and then you will find a page which, surprisingly, is good enough to cut carefully out and put into a mount and frame. Very small paintings eliminate some of the problems which larger ones present. But mainly and importantly draw for the fun of it (17-20). Draw everything and draw every day. Drawing is as important to the painter as practice to the piano player.

17, 18, 19, 20 *Sketches*, LORD THORNEYCROFT
Draw for the fun of it

My friend, John Ward, has for many years written letters to me and to my wife and illustrated them in his own delightful style of watercolour. All sorts of events in his life and in ours have been thus recorded and many of them have been framed and grace the walls of our house, reminding us not only of past events but of his friendship (**22, 23**). Drawing can be a most unpompous art. It can also be a great art form in its own right and it is this to which we now turn.

21, 22 *Letters to the author,*
JOHN WARD
All sorts of events in his life
and in ours

Drawing as an Art

William Blake: *Why, this is not drawing, it is inspiration.*
John Constable: *I never knew it. I meant it for drawing.*[1]

William Blake was, of course, a poet as well as a painter. His friend and
contemporary, John Constable, was a simpler character who found his art
under every hedgerow in his much loved Essex/Suffolk border country.
Yet each was right. Drawing at its finest can reach a point where Earth and
Heaven meet.

So far we have considered drawing as a technique and as a tool to assist a
painter in his work. But drawing is more than this. Drawing really starts
when it is concerned not only with the mind but with the emotions. This is
really what William Blake was saying to his friend all those years ago.

There is a term in oil-painting called alla prima – the placing of the paint
directly upon the surface of the canvas, leaving it there and placing another
stroke of paint beside it. The technique excludes special underpainting or
working over the paint as it is applied. In a sense all drawing is alla prima.

> The moving finger writes
> And having writ moves on.
> Nor all thy piety nor wit
> Will lure it back to cancel half a line,
> Nor all thy tears wash out a word of it.[2]

Well, perhaps not quite true in the days of the india-rubber, but true
enough in the practice of the great draughtsman. The line is drawn with
pen or brush or pencil with the artist expressing by it his first statement of
intention or of his reaction to what is before him. It will have degrees of
error and imperfection, but he has made it and he will not subsequently
deny it. It will in itself determine what the next line will be. Error and
variation from the truth will accumulate as he works, but strength and
beauty and meaning will accumulate as well. When one looks at the
drawings of the masters – at Raphael or Tiepolo – one sees an art form so
complete within itself that one wonders why anyone should wish to carry
such work further. And there indeed is the rub. For in a painting how does
one maintain the fluency, the immediacy, the passionate sincerity of the

early drawing? I defy anyone, even the greatest, to square up a drawing and then paint it upon a squared-up canvas without losing something in the process. Let me illustrate these thoughts by two examples.

Some years ago there was an exhibition at the Hayward Gallery of Italian fresco. A technique has been developed of pulling the fresco, with the plaster upon which it was painted, from the wall. This often left behind an original sketch known as a synopia. In the Hayward Gallery exhibition it was sometimes possible to see the synopia or first intention alongside the final painted fresco. Among these was *Christ appearing to Saint Bernard*, School of Perugino *(23, 24)*.

To my mind the synopia is superior and much more moving than the finished work. The hands and arms reach up toward the battered body of Christ with a tenderness and compassion which I fail to find in the final painting. Whether I am right or wrong in this judgement it is, I think, undeniable that the first intention – the very immediacy of the drawing – the once and for ever statement of a considerable artist, must always retain a beauty and meaning of its own which can hardly ever be wholly recaptured.

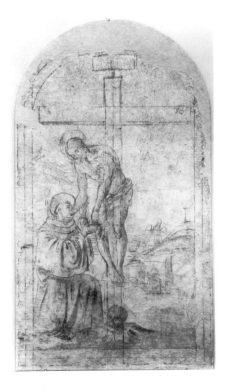 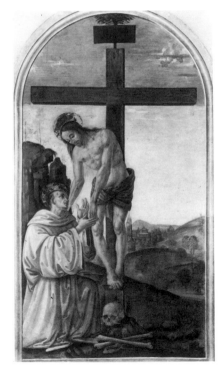

23, 24 *Christ appearing to St Bernard*, School of PERUGINO
The arms reach up . . . with a tenderness and compassion

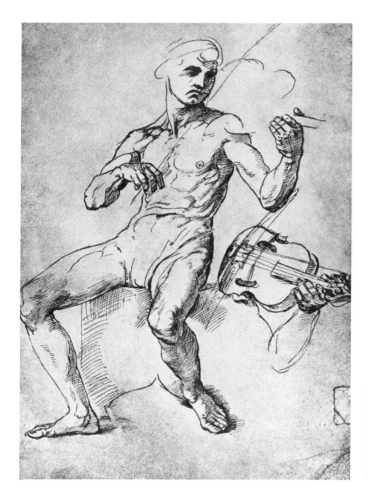

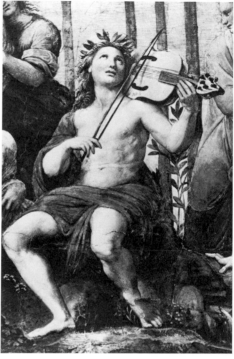

25 *Apollo Playing a Musical Instrument*, RAPHAEL
One of the really great drawings

26 *Detail of 25 from fresco 'Parnassus'*, RAPHAEL
His mind on higher things

I will give you the other illustration of the argument. Raphael made a pen and ink sketch for the central figure of Apollo in the great fresco *Parnassus* in the Vatican. It is to my mind one of the really great drawings in the world. It is, I hope, neither blasphemy nor a derogation of that masterpiece to say that the drawing captured the passion and vigour of the player concentrating his all upon the instrument that he was playing more impressively than the finished painting in which Apollo clearly has his mind on higher things (**25, 26**).

There is a lesson in this for all who paint – it is to strive with all one's might to keep the fluency of the first lines we draw with pencil, pen or brush flowing on throughout the painting.

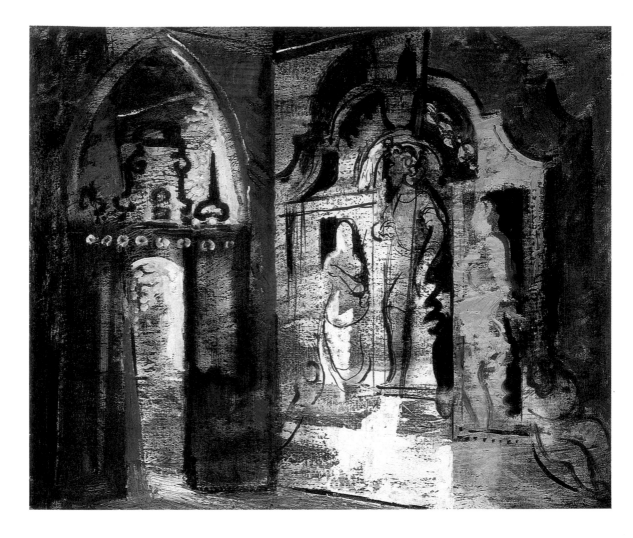

27 *Monuments, Yarnton*, JOHN PIPER
Drawing almost lost

It is very easy to turn a living drawing into a dead painting. This is true of oil and watercolour alike. I certainly do not claim that I know how to avoid this calamity in my own work or how to advise you to avoid it in yours. I can say what I observe in the works of others. Monet and the Impressionists largely kept the fluency of their paintings by painting direct from nature. The sheer physical strain of painting in the open a snow scene at Vétheuil must have been considerable, but there is a panache about this type of work which carries an immediate impact. Other painters achieve the result by stopping painting soon enough. Unfinished oils have an attraction all their own and we have all seen many paintings, which at one

stage were quite good, ruined as the painter battles on in an attempt to improve them. Cézanne was an adept at stopping at just the point at which the painting had reached as it were a climax.

Some have approached the problem by hardly drawing at all. There was, I understand, no school of drawing in Venice during the period when the masterpieces recently shown in London were in fact produced. The Venetian approach was less in line and more in blocks of colour. This approach at least has the merit of success in that it produced some of the world's greatest masterpieces. We are now most of us taught, and I believe rightly, to use both techniques.

Every painting should contain an element of drawing; it may be almost lost as the work proceeds, and perhaps only half recaptured at the final stages, but it provides a kind of basis or skeleton to the total structure.

The work of John Piper illustrates the theme, combining quite closely and accurately drawn architectural detail with floods of colour which at many points almost obliterate it and yet draw some disciplined meaning from it (27).

The lesson for the amateur watercolourist in all this is to be grateful for the fact that he paints in watercolour. The very nature of the medium, even its own difficulty, in some ways compels a continuity in the painting which gives at least an impression of fluency in the finished work. A good watercolour is drawn throughout, sometimes with pen or pencil but mostly with the brush itself in broad or narrow sweeps of colour. Drawing and painting a picture in this way is obviously a high-risk occupation. The failure rate for amateurs, at least in the early stages, is considerable. But I have found that even near-misses can often have a beauty of their own, and every now and again for all of us there is a bull's-eye.

Having considered a little how we draw, let's turn to the vexed question of how we put on the paint.

Painting

No man hitherto had painted the clouds scarlet.[1]
JOHN RUSKIN (on Turner's colour)

Painting in watercolours is certainly something difficult. Yet to paint a good watercolour is not impossible. I would go further. Though watercolour is intrinsically rather more difficult than oil paint, there are probably more good watercolours painted by amateurs than oil paintings. What is required in the approach? The first and most important element is courage.

'Our principal enemy,' Whistler once said to Sickert, 'is funk.' This fear of the thing is indeed an important element in painting which is encountered by amateur and professional alike.

The timidity of the painter is reflected in the hesitations of his brush and permeates the whole of any work. Bold strokes of the brush, even though they incorporate some elements of error, as in the early stages they most certainly will, are much to be preferred. Study well the works of Hercules Brabazon. Study them just because they contain many imperfections. Brabazon went, often with brilliant success, straight for the main effect.

Was the wall of a building in Venice pink? Then he filled his brush with colour and stroked it boldly down (**72**). Go for the thing that really strikes you about the subject, if you can interpret that, much else will follow. D. S. MacColl, one-time Keeper of the National Gallery of Modern Art (now the Tate Gallery) described the work of this amateur watercolourist as follows: 'when the ordinary man would have been losing the precious moments in counting windows and measuring bricks, this painter saw nothing but a blaze of pink light on a palace front and the bewildered dance of colour in the canal.'[2] Brabazon's courage shines out in his paintings.

We should, I think, try to draw a little before we start to paint. Not everyone would agree with this, but some kind of a disciplined structure gives confidence to the amateur as he embarks upon the problem of how to put colours on whatever surface he has chosen for the purpose. One can learn to draw, but somehow I rather doubt if one can actually learn to paint. One can find one's way towards it by trial and error, by taking lessons, by reading books, and, above all, by watching others and studying

other paintings. But painting is too complex and personal an adventure to be capable of detailed transmission of a technique from one person to another.

The most important thing in painting is not to be afraid of it. People, after all, paint with almost anything – with oil, water, turpentine, eggs, gum arabic, varnish – you name it, they use it, and they mix it with paint and apply it with brushes, with fingers, with bits of cork, with blow-lamps, sticks, with pens or pencils or anything that comes to hand. They pour ink on paper and blot it while wet into another sheet and use the transfer for the inspiration for a painting. They mix all these methods up, placing one medium upon another as their fancy takes them. Anything, literally anything, goes. There is, I believe, something to be said for trying out some of these techniques. They kind of loosen things up. Teachers are mostly ready to demonstrate them, and admirable books exist to help one.

One should, perhaps, at the same time major on one technique. I happen now to major on a pure watercolour technique and what I have to say about painting is primarily but not exclusively concerned with that.

While this is not a book about how to paint in the sense of setting down a list of materials required or how to lay on a wash of colour, I feel bound to say that the problems of the amateur are much reduced if he pays attention to certain basic requirements at the outset. There are thousands of beginners who wander round attempting to paint watercolours with equipment which would in my judgement defeat the efforts of even a master of the art. My advice is this. Recognize that you are now moving from sketching to painting. Don't use lightweight papers. They can be very lovely but when wet swell into a kind of mountain range. Don't, for a start, try all the rigmarole of stretching paper on board; it helps, of course, with thin paper but it's not really necessary with thick. If you like this sort of thing, spend the time papering the bedroom. Instead, buy some proper paper, by which I mean paper graded at a weight of not less than 175 lbs, which means a pretty thick one. Don't, at least not yet, buy a rough one. Painting is hard enough without trying to paint on a surface like a ploughed field. I use a Fabriano 175 lbs (smooth), but any paper of this type would do. You will need to cut the sheet up to get a piece the size you want and place it on a board.

About the board; you will find that 12″ × 17″ is a convenient size and that folders can be bought which will hold this with a few sheets of your paper cut to about the same size. There is, however, a snag. The ordinary art shop sells beautiful boards, but they are designed to stretch paper on and are thick, inconvenient and remarkably heavy. Avoid them. You need a light, thin board, 12″ × 17″, and if you can't get it from an art shop, buy it from a carpenter or timber merchant. Hardboard will do but hard wood is better, because if the hardboard gets very wet it will warp. Fasten the

paper to the board with either broad pieces of elastic or non-projecting bulldog clips or both.

You need a paintbox. They sell, and I often use, a very small one – it is, however, really designed for sketching. I have come round to using a fairly large box with full-size pans for the paint and deepish hollows for mixing a wash. Finally, your brush. I'm afraid that a brush suitable for anything more than small sketches will set you back a bit. You need a large (at least No. 11 or No. 12) sable brush. Nothing else is capable of the clear, brave strokes you ought to bring yourself to make. Use others as well if you like, but with this you can do most of the work. With this equipment you can really paint.

You can paint on the paper dry, or you can wet the paper quite a lot and paint on that. It won't ruck up and wrinkle. It won't be easy, but at least it won't be impossible, which is quite a start.

Armed with this surface, you settle down to paint. You do not have to cover the whole surface. Small paintings are easier to start with. You draw a little to indicate a few salient points. Then you start to paint. But how?

Broadly, there are two extremes of watercolour: the coloured drawing and the pure watercolour. Both are valid approaches to a finished work and there are, of course, a mass of situations in between.

Consider first the Rowlandson (**29**). It is basically a coloured drawing and you would have to draw very well to match the wit and insight contained within it. Look now at the Wilson Steer – not a pencil line visible upon it (**30**). You can try both approaches. The paper in the Rowlandson was dry when he drew upon it. The paper used by Wilson Steer was pretty wet. One can, of course, learn the techniques but no one will ever teach you how to paint either of these pictures. Their secrets are not to be found in the art classes or the books, but look closely at such paintings.

I recognize, of course, that however hard we try, few amateurs will ever match the dashing draughtsmanship of Rowlandson or the mastery of the 'wet into wet' painting in which Wilson Steer excelled. Most of us would be wise to study rather simpler techniques. If courage is a prime requisite of watercolour painting, 'simplicity' must run it very close. The amateur could do much worse than study the watercolours of Sir Hugh Casson. He has, after all, been President of the Royal Academy, and paints with a directness, a simplicity, and a lack of affectation that carry an immediate appeal (**28**).

Paintings speak for themselves, and it would be presumptuous to seek to identify the quality which makes paintings like those of Hugh Casson so outstanding. In part, however, the key lies in his determination not to finish them, to leave much to the imagination, to let ink and paper speak for themselves. This approach has respectable antecedents, for it was the hallmark of Cézanne, perhaps the greatest watercolourist of them all.

28 Turner's House at Twickenham,
SIR HUGH CASSON
Let ink and paper speak for themselves

29 *The Ballad Singer*, THOMAS ROWLANDSON
Basically a coloured drawing

30 *Haresfoot Park, Near Berkhampstead, Herts*, WILSON STEER
Not a pencil line upon it

In the end every painter must choose his own style. One can with difficulty learn a little how to draw; one can learn something about composition; one can learn some tips about how to mix paint or put paint on canvas or on paper, but in the final analysis painting is like handwriting. Wise teachers do not attempt to change dramatically the style of those they teach. A teacher's relation to a student should rather be like that of a monarch to a prime minister – to advise, to counsel and to warn.

It will, I hope, be consistent with this if I describe what it feels like to me to paint a picture. Different amateurs paint wholly differently but some will recognize the problems, doubts and uncertainties which I now refer to.

I have arranged some gardenias in a blue vase and placed them against a dark background. I have fixed some paper on a board and indicated not in any great detail but fairly clearly the edges of the vase and where the principal flowers and leaves appear to be. I am ready to paint.

The expanse of white paper before me is both my enemy and my friend. My enemy because, left as it is, it will distort every colour which I place upon it. My friend because it is the only thing available to represent the highlights in the scene before me. Look, therefore, and look again and again to see where those highlights are. Guard them from any touch of colour, at least for the moment, for once lost they can never be recaptured. If, as in the picture of gardenias, the background is dark, make it dark upon the paper and do it boldly. Mix a generous supply of dark colour, dampen the paper, brush it boldly in; leave all else alone, including particularly the fallen blossom on the table. Next start in upon the central, still white, area in the middle; the leaves, the bowl, the dark areas in between, leaving only the gardenias.

About this stage you will despair. Press on. Darken still more some of the surroundings of the flowers and the leaves, drawing bravely with the brush. Still guard your precious lights given to you by the whiteness of the paper. Finally, touch in the shadows in the actual flowers themselves.

If the background looks too blotchy, dampen a face cleaner and gently smooth it down. Take a final look to make sure the darkest bits are really dark and the job is finished. It's not a Fantin-Latour, but in a kind of way it works (31).

In all this I have spoken of light and darkness, the contrast between them. This is what is known as the weight of colour. The way you do it and the weight you give the various areas is just as vital as any drawing. It is possible to make a lovely painting with one colour only, such as grey or sepia, and rely upon the varying weights alone.

I now turn to colour. This, frankly, is where I think that the professionals have the edge on us amateurs. You have looked very hard at the subject in order to draw it. You have looked even harder to judge the weight of dark and shade about it and within it. Think always of that light and shade, and

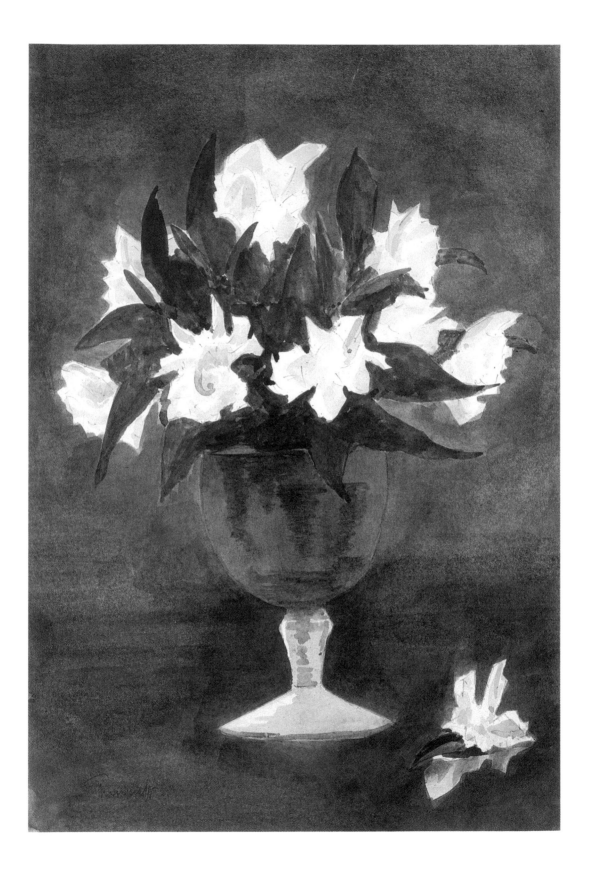

whatever you now do don't lose it. You must learn, however, to look hardest of all to see colour. Teachers and books will help you to mix colours and help you to recognize their relationship to each other. Actually to see them is more difficult. Just as some people are colour-blind, all, I think, vary in their perception of colour. Shadows are not, or only very rarely, just black; they are reddish with warmth or blue with cold. Seek to see these things, which give real life to painting, and do not fear to exaggerate them enough to make the impact they deserve. Look for the reflection of a woman's dress in the colour of a woman's cheek.

There is a saying that you paint from dark to light in oils, and light to dark in watercolours. Certainly it is relatively easy and attractive to introduce light shades on dark oil paint on a canvas. In watercolour it is for general practical purposes very hard to do this. This does not mean that you cannot paint in some dark areas early. Indeed you should, but knowing that, once they are done, you generally remain committed to them. It is then in the balance between the design, the weights of light and shade and the colour on which the finished watercolour will rest.

I know that it sounds difficult, and sometimes it works and quite often it doesn't. It sometimes works as though by a miracle, the washes glow smoothly on the paper, the darker areas appear, the highlights gleam whitely where they should. If you manage to paint often like this, good luck to you. Sometimes it is more of a battle.

Don't shirk a battle for a watercolour. Indeed, the amateur is well advised to fight a few in order to see how far he can press the use of paint and water upon paper.

Watercolours, particularly when painted on a good thick paper, are much tougher than is generally supposed. You can soak them, scrub them, dry them, paint them again, often with very good results. We are fortunate to have an eye-witness account of Turner painting one of his most famous watercolours, *The First Rate Taking in Stores* (**32**). Turner was a close friend of the Fawkes family of Farnley Hall. There exists in the National Gallery an account by Mrs Edith Mary Fawkes, daughter-in-law of Walter Fawkes's third son, of the painting of this picture by the great artist.

There is one thing quite certain as to the Turner traditions of Farnley for I have heard it repeatedly stated by all the generation who were children when Turner was much at Farnley, and that is that with one deeply interesting exception, no-one ever saw him paint when he was there.

The exception was this. One morning at breakfast, Walter Fawkes said to him 'I want you to make me a drawing of the ordinary dimensions that will give some idea of the size of a man of war.' The idea hit Turner's fancy, for with a chuckle he said to Walter Fawkes' eldest son [Francis Hawksworth Fawkes], then a boy of about 15, 'Come along Hawkey and we will see what we can do for Papa,' and the boy sat by his side the whole morning and witnessed the evolution of *The First Rate Taking*

31 *Gardenias in a Blue Vase*,
LORD THORNEYCROFT
In a kind of way it works

in Stores. His description of the way Turner went to work was very extraordinary; he began by pouring wet paint on to the paper till it was saturated, he tore, he scratched, he scrubbed at it in a kind of frenzy and the whole thing was chaos – but gradually and as if by magic the lovely ship, with all its exquisite minutiae, came into being and by luncheon time the drawing was taken down in triumph. I have heard my uncle give these particulars dozens of times. . .

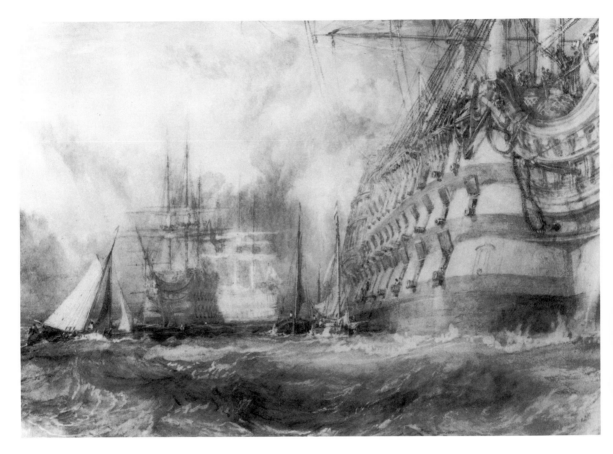

32 *The First Rate taking in Stores*, J.M.W. TURNER
'Gradually, as if by magic, the lovely ship came into being'

This story is no doubt accurate at least in its main particulars. It throws an interesting light upon the relations between Turner and his great patron, Walter Fawkes. It indicates that this remarkable and famous painting was completed in the space of one morning. It would seem to show that at some stage it was pinned up, no doubt to dry a bit before it was 'taken down', but above all it shows that a great artist of experience can handle his materials with quite remarkable abandon and produce at the end of it a painting of both power and sensitivity.

There is an account also from the same source of one of Walter Fawkes's daughters asking the great painter for advice on one of her watercolours. Turner pondered his reply and then said, 'Put it in a jug!' The suggestion was, in the light of his own proven methods, an entirely helpful one. There can come a moment when a good soak is just what is required.

I am always fascinated by first-hand accounts of how good artists painted. There is a spirited passage by Mary Newpold Patterson Hall on the 'Sargent I knew' in Ratcliff's book on that painter.[3]

To see one of Sargent's watercolours in the making always reminded me of the first Chapter of Genesis when the evening and the morning were the first day, order developed from chaos, and one thing after another was created of its kind. Having chosen his subject and settled himself with sunshade, hat and paraphernalia all to his liking, he would make moan over the difficulty of the subject and say 'I can't do it' or 'it's impossible' and finally 'well let's have a whack at it'.

Perfect absorption would then follow and after what looked like a shorthand formula in pencil on the block, the most risky and adventurous technique would come into play, great washes of colour would go on the paper with large brushes or sponges, and mutterings, 'Demons, demons' or 'the Devil's own' would be heard at intervals.

All the time the picture was growing surely, swiftly. He worked through to the end, only stopping when light and tide changed.

So don't imagine that painting watercolours is done by mastering some quiet, orderly technique and just applying it. You will learn more from watching an artist paint than from listening to him. Above all, don't try to be tidy. Try to be brave. And don't let failure disappoint you. Others have failed before.

I recall these events not to encourage the amateur to adopt the artists' methods in all their full vigour, but to emphasize that courage in painting can often be rewarded, that experience opens up all sorts of methods to the painter and that painting is anyway best approached in a rather relaxed and even experimental way with the knowledge that if one experiment fails it will at least add to one's knowledge and increase the chance of finding more success next time.

Painting is in any event a joy and a great adventure.

Beyond Technique

There is a joy in painting that only painters know.[1]
WILLIAM HAZLITT

There is, of course, a large gap between knowing how to paint and producing a good painting. A painter needs more than technique, he needs a kind of vision. Great painters certainly for the most part draw rather well and put on the paint very bravely. Great paintings, however, rest upon other claims than these. A man who has learnt to draw an object and put on some colour is no more a painter than a man who has some knowledge of grammar is a poet. I would not seek to lay down rules about how an amateur should approach one of his paintings, but I would urge the value of simplicity.

People learn to play the piano by learning rather simple pieces often composed by great masters. There is something to be said for adopting the same approach in painting. Pieces of music scored for full orchestra with drums and extra trumpets are not for starters. So with painting. The interplay of line and mass and colour is just as hard to handle as a musical concerto. It can just as easily get out of hand. If you are a genius it is, of course, quite different; but if you are a genius you have been very polite to read as far as this – look then at the work of other painters to see not only how they painted but what they chose to paint.

Most amateurs in this country paint largely landscape. It was not always so. Two hundred years ago landscape painting was something new and strange. Everything outside the city wall or well-ordered park or garden tended to be thought of as a strange, wild place. It was the dark wood described by Dante. The discovery of landscape in this country happened to coincide with the discovery of watercolour as a possible and popular means of expression.

An important aid for the amateur, then, is to look at the work of those painters which I shall presently describe. Look, however, most especially at the quick inspired sketches which they did. These sketches often tell us more about the art of painting than some of the more fully finished works prepared for exhibition.

Painters have a knack of concealing the struggles through which they

laboured in arriving at the finished work of art. In 1948 Matisse wrote: 'I have always tried to hide my own efforts and wanted my work to have the lightness and joyousness of Springtime which never lets anyone suspect the labours it has cost.' Try then to catch the great painters in their more unguarded moments. Look at this sketch for *The Valley Farm* by Constable (**33**). It is in brown ink and wash. Try making some landscape sketches in this restrained and unpretentious medium. Look at his sketch of *Flatford Lock* (**34**). One understands what William Blake meant when he said to Constable, 'This is not drawing, it is inspiration.'

33 *Valley Farm*, JOHN CONSTABLE
Catch great painters in their more unguarded moments

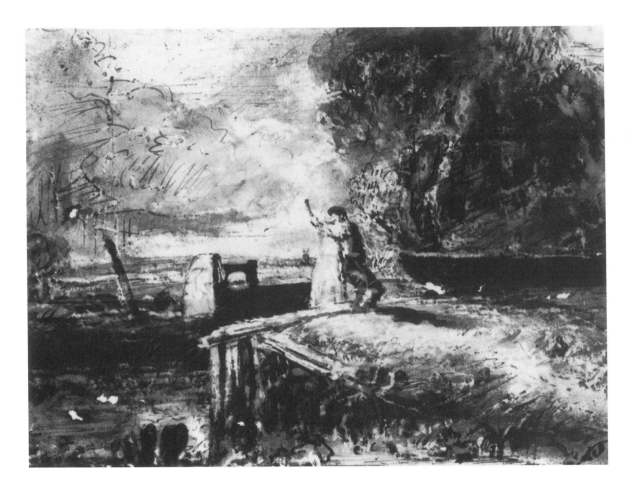

34 *Flatford Lock*, JOHN CONSTABLE
Not drawing – inspiration

Another painter whom every amateur should study is Gwen John (1876–1939). Consider this portrait of her seated cat in pencil and watercolour (**35**). Your cat, by the way, is always a good subject for a portrait – it will make no complaint about the expression you have given it. Gwen John painted quiet, understated paintings of her room, her cat, the children in the village, a few figures in a church. We may not match the masterly paintings which she made of these simple subjects, but we can learn from the quiet simplicity of her approach and try to understand the mixture of shape and tone or colour which makes her one of the most distinguished painters of her time.

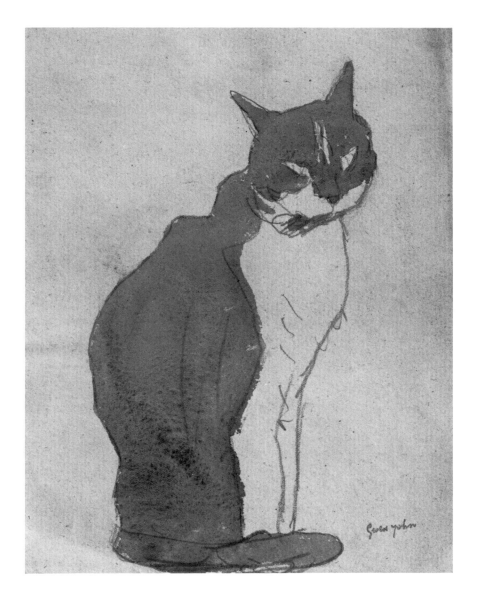

35 *Seated Cat*, GWEN JOHN
Quiet simplicity of her approach

If you want to understand great painting, look, if you can find it, at the kind of sketch or drawing that underlies it. I always think that Rembrandt's sketch of a sleeping girl – put almost carelessly upon the paper, so apparently simple – illustrates how tantalizing is the difference between really great painters and the rest of us (**36**).

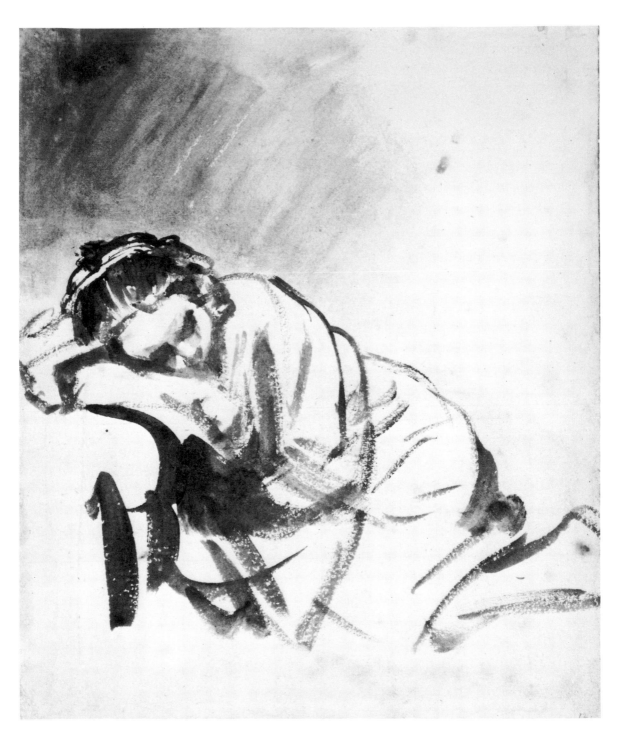

36 *Sleeping Girl*, REMBRANDT
So apparently simple

True artists see beauty more readily than other men. What they see, the words they read, the music that they listen to can all move them to some painterly interpretation. They know by a kind of instinct what aspects of a scene to capture on their canvas or their paper. The amateur with an eye less trained tends to rely more upon the beauty of the subject painted to lend beauty to the painting. There is, of course, no shame in this. I am perhaps happiest when I paint in Venice. The problem there is not to find beauty but to select from such a range of attractive possibilities. Venice is, however, kind to the amateur. She often presents her treasures ready framed for him at the end of the tall, shaded *calles* which form the streets of that delightful city (**37**). I would not advise trying to paint the Venice of Guardi or of Canaletto. There is a secret Venice of carvings and columns and Gothic windows half-hidden by the shadows like a woman glancing out from behind a fan. This is the Venice to search for and to paint.

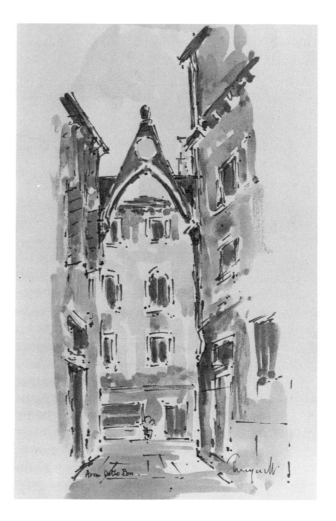

37 *Calle Arco Detto Bon*, LORD THORNEYCROFT Venice presents her treasures ready framed

The amateur will, I think, quite properly be hesitant about painting portraits – particularly in watercolour. Portrait-painting has psychological as well as painterly problems. The subject as well as the relations of the subject will all have views about the result. Not for nothing has it been said that a portrait is a painting with something wrong about the mouth. The problems, I must admit, are multiplied by the use of watercolour, a medium which is often better suited to the broad impression of a situation rather than the detail, often attempted on a small scale, of a feature in the sitter's face. The answer is to stick to the broad impression, leaving photographic likenesses to others. Look closely at Gwen John's painting of two figures in a church. If you can't paint them from the front, paint them from the back (**38**).

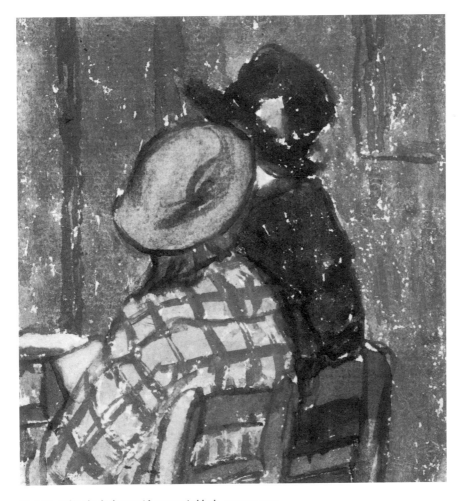

38 *Little girl in checked coat with woman in black*, GWEN JOHN
Paint them from the back

The amateur will, of course, also paint still life. Still life consists in the painting of a group of objects in their own right separate from any figures or landscape associated with them. This type of painting dates back to very early times. Still life is to be seen painted on the walls of Pompeii or upon the tiles produced for the floors of old Roman villas.

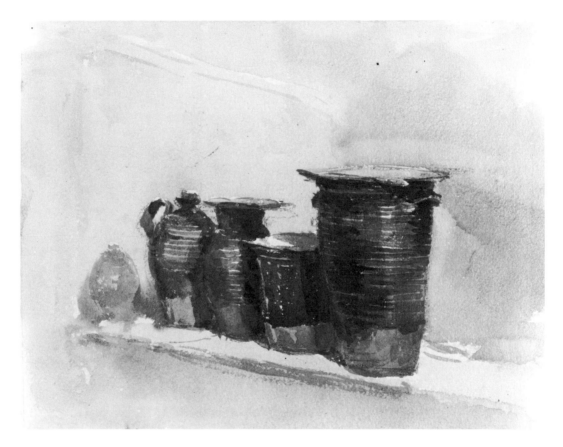

39 *Still Life*, DAVID COX
The simplest paintings by the great masters

The selection of the still life can be almost as difficult as the painting of it. The amateur will be well advised to admire but not to emulate the large, complicated still life compositions produced with such brilliance particularly in Northern Europe and containing fish, fruit, vegetables, knives, suits of armour and much else. Seek simpler arrangements. The kitchen may provide better material than the drawing-room. Study a rare still life by David Cox of a row of pots (**39**). Look carefully at the work of Chardin, Vuillard, Fantin-Latour. Take the simplest paintings by the greatest masters as an indication of the kind of thing to aim for.

40 *Spitz-Hüte*, PAUL KLEE
Look beyond the frontiers of the conventional

You may of course feel that all this is very conservative and conventional. What after all is happening to the avant-garde in painting? Quite a lot, but, oddly enough, not very much in watercolour. The Institute of Contemporary Art does a good job in searching for and presenting new trends. The tendency at least in the visual arts seems to be to go for size, for painting on canvas, for opaque media, for spray guns but rather to neglect the opportunities presented by the transparent washes of pure watercolour. None the less some of the moderns have achieved great work

of an abstract nature within the restraining disciplines of a watercolour technique. Study the work of Paul Klee. His painting *Spitz-Hüte* (**40**), executed in pen and black ink, brush, grey wash and watercolour deals in an abstract form with a subject not wholly dissimilar to Rembrandt's *Sleeping Girl* (**36**) but in an abstract idiom. Between them these paintings serve to illustrate the beauty that can almost equally be achieved either by the representation of nature or by abstraction from it. They share a kind of balance, a sincerity, a lack of sentimentality or affectation. This is not a book about abstract painting, but the amateur should certainly not ignore what is happening beyond the frontiers of the conventional.

There is much anyway to be learnt by looking closely at the boundaries between the abstract and the representational upon which Graham Sutherland moved so easily. At the very least, experiment. Put aside for a day your smaller brushes. Take large sheets of paper, large brushes and a bucket for the water and enjoy changing the whole scale on which you paint.

It is good, indeed vital, to learn techniques, but it is perhaps not a bad thing also to forget them. Good painting, particularly good watercolour painting, is a kind of balance between discipline and freedom, between the most delicate beauty on the one hand and well defined and stated form and strength on the other. These things cannot be taught – they can only be found by painters in the actual handling of paint and water upon paper.

Painting, then, in the final analysis, is not simply a technique but a way of looking. There is no shortage whatever of technically competent paintings; there is a limit to the number of paintings of real artistic merit. We amateurs are not, of course, in the business of painting masterpieces, but we should seek to see more vividly the beauty that is all around us. We should study hard to see how others have learnt to select and capture it and how they have managed to find it in quite unexpected places. I have found it helpful myself, and other amateurs may find it helpful too, to study rather closely the works of the watercolourists of the past, and it is to their example as both professionals and amateurs that I now turn.

Past Masters

The General must not only reconnoitre the battleground he must also study the achievements of the great Captains of the Past . . . you see the difficulty that baffled you yesterday and you see how easily it has been overcome by a great or even by a skilful painter.[1]

WINSTON CHURCHILL

An amateur is well advised to study the work of the past masters of his craft. By doing so he will find an almost limitless opportunity to examine every variety of painting and to learn at least something of the ways in which others have tackled the problems which confront him.

Admirable books exist about the history of watercolours. (Some are listed in the Bibliography.) Martin Hardie's definitive study in three volumes, *Water-Colour Painting in Britain*, is compulsive reading for any serious student. Iolo Williams's *Early English Watercolours* and, for lighter but valuable reading, Michael Clarke's *The Tempting Prospect*, are highly recommended. In this book I do not attempt a history of watercolours but more a series of suggestions as to how and where to look for them. Inevitably when one touches upon the history of painting one tends to divide painters into periods or schools. It is, I think, wrong to regard them thus. A painter is important for what he paints, not for any school to which he may belong. Painters rise and fall in popularity with the fashions of the age and with the whims of those who write about them. The amateur should try to look at their paintings without some preconceived standard of judgement.

Each combination of lines and washes and colours meant something special to the painter many years ago. They were his personal statement and interpretation of what he saw. They are there today and transmit the message, which was so immediate and important to him, direct to us. Of course paintings vary very much in the impact that they make, but sometimes you will catch a glimpse of the magic which moved the man who painted it.

It is through these experiences that one learns about paintings and sometimes learns a little about how to paint.

There are three main periods of English watercolour: the Pioneers, when the art of continental topographical painters was being adapted to landscape and developed here with rather imperfect materials; the Middle Years, 1750–1850, when Britain witnessed an upsurge of watercolourists

unmatched in any other country; and the Aftermath, which comprised a complex of influences and movements leading to an important admixture of continental painting to produce the work of the early twentieth century. I will say something first about the professionals who contributed to these events.

It is important to remember that the period which spanned the end of the seventeenth and the beginning of the eighteenth century marked a high spot in the history of British painting. This was the age of Lely (born 1618), Kneller (1646), Arthur Devis (1711), Stubbs (1724). It was an age of great portrait-painting. It was an age for the miniaturist. It was a time for the sporting painter and the painter of animals. Above all, it was the age of the greatest English satirist in paint, William Hogarth. A man could have a painting of himself, of his wife, of his family grouped about him with his dogs, of his horse, but he would be hard put to it to find a straightforward painting of the British countryside.

Gainsborough, who was certainly capable of painting a landscape, just didn't want to know. He wrote to a patron who had asked for a painting of his park:

Mr Gainsborough presents his humble respects to Lord Hardwicke and shall always think it an honour to be employ'd in anything for his Lordship, but with regard to *real views* from Nature in this country, he has never seen any place that affords a subject equal to the poorest imitations of Gasper or Claude. . . Mr Gainsborough hopes Lord Hardwicke will not mistake his meaning, but if His Lordship wishes to have anything tolerable of the name of Gainsborough, the subject altogether, as well as the figures, must be of his own brain. . .[2]

Poor Lord Hardwicke, who probably thought that the park of which he was so proud had a certain beauty, would have liked to see it recorded – whatever was in anybody's brain!

But that was the way of things in those days. Fuseli, the keeper of the Royal Academy, was referring in his lectures to 'the last branch of uninteresting subjects, that land of landscapes which is entirely occupied with the tame delineation of a given spot'. As the late Lord Clark pointed out, this was said when Constable was already a student at the Academy schools and must fall into the category of famous last words.

The Age of Reason had, if not an urban, at least a well ordered, rather neatly arranged, architectural centre which took less account of the English countryside than the French painters such as Claude and Poussin were taking of their own.

Watercolours were scarce, and when found approximated more to coloured drawings than the paintings which we know today. The break-through into watercolour and in particular into watercolour landscape was not a wholly British initiative. The Dutch had for many years played a role

as topographical draughtsmen in England in an age which did not yet know the camera. In 1636 Thomas Howard, Earl of Arundel, on a mission which took him through Germany, met and employed one Wenceslaus Hollar (1606–1677) who was born in Prague and was basically a printmaker. The Earl employed him as a topographical draughtsman. In Arundel's own words, he 'drawes and eches printes in strong water quickeley and with a pretty spiritte'. With a few years' break during the Civil War, Hollar remained in England till his death. He became known at the Court of Charles I where he was appointed drawing master to the Prince of Wales, the future Charles II. According to his friend the English amateur, Francis Place, of whom I will say more later, 'Mr Hollar had a defect in one of his eyes, which was the left, so that he always held his hand before it when he wrought'.

41 *View, North Bank of Thames*, WENCESLAUS HOLLER
Thought Britain was worth painting

He was clearly a man of some spirit and courage who lived and worked in London during the plague and drew landscapes of London and many castles and abbeys (**41**). Our knowledge of London of those days and what it and the people in it looked like owes much to his work. He died in poverty in Gardeners Lane, Westminster, not knowing that in his life he had made so large a contribution to advance the art of painting from mere topography to landscape. His importance lies not simply in the paintings and etchings that he made but in the fact that he was one of the earliest painters to think that Britain was worth painting. His art was closely mirrored by the amateur Francis Place and he was followed by the earliest of the great British watercolourists, Paul Sandby (1725–1809), who launched out in landscapes in watercolour. For this purpose Paul Sandby encouraged William Reeve to manufacture some of the earliest watercolour paints which came at last within the area of what we have today.

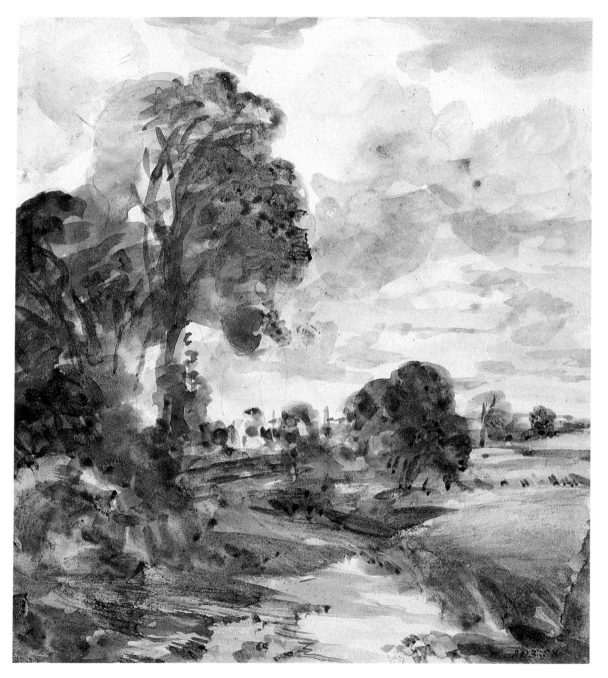

42 *Study for a Landscape*, JOHN CONSTABLE
If I had to choose one painting. . .

The final bridge to the Golden Age of watercolour landscape was perhaps built by John Crome (1768–1821), sometimes called Old Crome (**43**).

Do not distress us with the accidental trifles of Nature, but keep the matter large and in good and beautiful lines; and give the sky, which plays so important a part in all landscapes, and so supreme a one in our low level lines of distance, the prominence it deserves, and, in the coming years, the posterity you paint for shall admire your work.[3]

It was with words like these that the Pioneers could usher in the now-famous names who were to launch the great age of British water-colours which lay ahead.

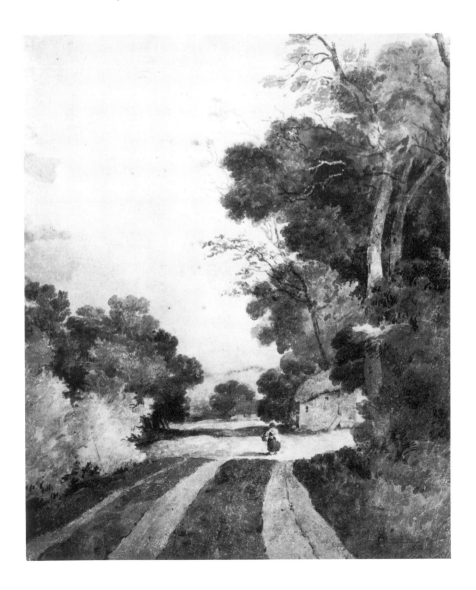

43 *The Shadowed Road*,
JOHN CROME
'Do not distress us with the accidental trifles'

Between the middle of the eighteenth century and the middle of the nineteenth century, a development in the art of painting in watercolour took place in this country of a nature unmatched in any other part of the world. In this field of art it gained for us international renown which continues even to the present day. In its way, and of course in minuscule, it resembled the upsurge of painting in the Italian Renaissance. Over a relatively short period a substantial number of outstanding painters revolutionized the use of watercolour as a medium.

They were nearly all born in the last fifty years of the eighteenth century and completed their work and lives within the first half of the nineteenth.

A description of the work of these painters would require a volume. Indeed volume II of Martin Hardie's *Water-Colour Painting in Britain* is largely devoted to them. The best way for the amateur to appreciate their work is not to read about it but to see it. Fortunately it is fairly widely represented in museums and art galleries throughout the country (see page 146). All these men were painters of such quality that it would be wrong to put them into narrow and separate categories. Something may, however, be said about them if only to indicate some of the things to look for.

Starting with what might be called the central strength of the English school who painted almost exclusively in their native country, Paul Sandby (1725–1809), John Crome (1768–1821), Thomas Girtin (1775–1802), Joseph Mallord William Turner (1775–1851), John Constable (1776–1837), John Varley (1778–1842), John Sell Cotman (1782–1842), David Cox (1783-1859), and Peter de Wint (1784–1849), were the real masters of the English landscape. Constable was, of course, famous as an oil painter as well. His small oil sketches on paper have something of the freedom of his watercolours. Girtin in his lifetime was rated as at least the equal of Turner and exercised enormous influence on his fellow artists. Born in the same year as Turner, 1775, he died in 1802 at the age of twenty-seven. Turner had grown up with him in Dr Monro's informal academy and said of him, 'If poor Tom had lived, I would have starved.' John Sell Cotman is perhaps the most easily recognizable of the group. Look, particularly, at the broad simplified sweep of his colour washes and the effective way in which he concentrates upon the main lines of the structure while leaving out much of the distracting detail (**44**).

If I had to choose one painting to speak for this period, I would choose *Study for a Landscape* by John Constable (**42**). Everything that Constable stood for shines out in this small painting: his deep love and understanding of the English landscape and most especially of the Essex and Suffolk border, the deceptive, almost casual way in which he lays on the paint – the coloured shadows and the light beyond. If all a man can ever learn in painting is to increase the pleasure of looking at this one, his efforts will have been well worthwhile.

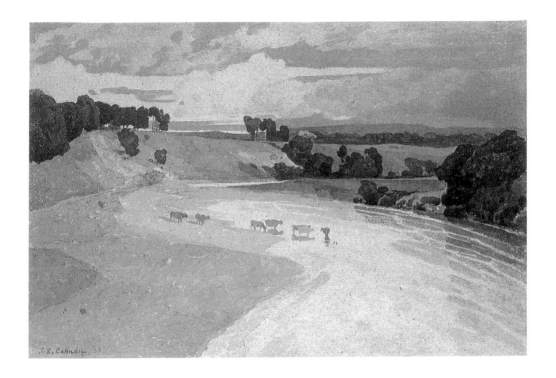

44 *Wooded Landscape*, JOHN SELL COTMAN
The broad sweep of Cotman's washes

This school of English painters was, of course, influenced by the continental painting of the period. They had seen paintings by Claude and Ruysdael and even copied them. But they drew their inspiration from their native countryside.

John Robert Cozens (1717–1786), Francis Towne (1740–1816) and many othes made the Grand Tour either alone or in the company of patrons. Their artistic vocabulary was, therefore, strengthened by a sight of the superb scenery, architectural and rural, of Europe and particularly of Italy. They both lived with and absorbed at first hand the landscapes of the Italian and French masters. As a result they have much to offer us.

John Robert Cozens was the son of the Russian-born Alexander Cozens, one-time drawing master at Eton, who had also taught the children of George III to paint. His patron was William Beckford. He painted exclusively in watercolour and in the great tradition of the English watercolourists of that period. Look at his painting, *The Lake of Albano and Castle Gandolfo. Evening* (**45**). It is steeped in the poetry of Claude Lorraine and presents his romantic view of the Italian landscape within a structure that owes much to that great artist. Francis Towne, though less famous, is at his best an equally impressive painter (**47**).

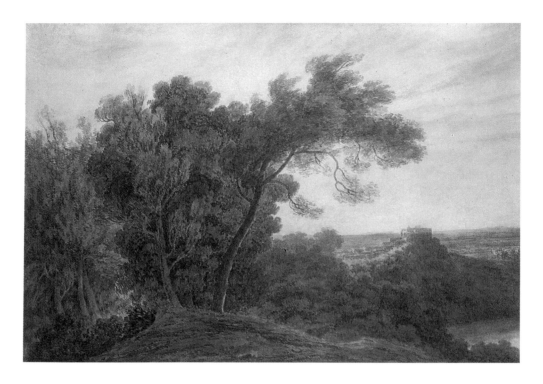

45 *The Lake of Albano and Castle Gandolfo. Evening*, JOHN ROBERT COZENS
Absorbed in the landscapes of the Italian and French masters

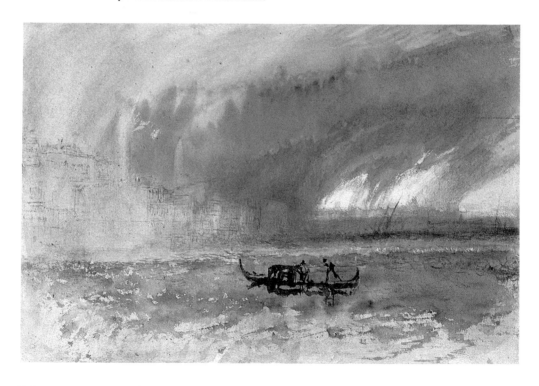

46 *Venice*, J.M.W. TURNER
Glimpses of buildings across water

47 *Lake Maggiore*, FRANCIS TOWNE
At home among the mountains

William Blake and to some extent the man whom in old age he befriended and influenced, Samuel Palmer, are essentially poets or at least deeply influenced by poetry in what they painted. If you take Dante's *Divine Comedy* as the subject-matter of a painting, you clearly travel a different road from the one you follow in depicting, say, the East Anglian countryside.

Two painters stand out on their own: Bonington, who in his short life painted almost exclusively in France and Italy, and exercised a marked influence upon French painting (his early death from tuberculosis put out one of the brightest lights of European painting) and Turner.

Turner was, of course, a great painter in oil and justly rated to be a master in that medium. It is, however, his watercolours with which we are concerned. He was a revolutionary in his age in the use of colour. Books

are written on his changing techniques. For my part, I would advise the amateur to search especially for his later watercolours, particularly of Venice, which, as he developed them, became increasingly abstract in their approach. They were then, when they were painted, and remain today something new and different in the approach to watercolour. The handling of form and colour present huge problems in any painting and Turner demonstrates in these Venetian paintings, these glimpses of buildings across water, these shadows of boats and glints of sunshine, a mastery of what can be done with paint which any lover of the art must watch, not only with delight but awe (**46**).

There were, of course, many more – among them Alfred Elmore (1815–1881). He straddled the end of the great period of watercolour. Elmore was an Irishman born at Clonakelly, County Cork, a member of the Royal Academy through his rather dull oil paintings. His watercolours came to light only in 1933 through the dispersal of a family collection. None of them are either signed or dated. They may represent his work while a student in Paris. They stand comparison with the great names of English watercolour.

The paintings of these men now grace the rooms of connoisseurs throughout the world. Twenty-five years before the oldest of these men was born, British landscape painting was rare and landscapes in water-colour almost unknown. Many factors contributed to this remarkable upsurge in the art of watercolour. As we shall see later, the amateurs played a part in these developments both as patrons and often as pupils of these professional artists, as did the technical improvements of watercolour under William Reeve and the forebears of the great firms of Winsor and Newton and of Ackermann.

Yet no explanation of circumstance or climate can account for more than the opportunity which now presented itself. The hallmark of this golden age of watercolour is to be found in the sweeping brushstrokes with which John Sell Cotman and others applied their paint; in the grasp of the essential forms and structures of the countryside, in the new mastery of colour and indeed the new vision and understanding of it. These were the factors which placed this country at the hands of a few men and over a relatively short span of years in the forefront of this art form. The finest education that any amateur can find is to search for and look at some of these truly great paintings. Modern printing methods provide of course some good illustrations of these painters, though nothing can match the thrill of seeing the originals.

The Victorians and After

There is nothing that I can tell you with more eager desire that you should believe . . . than this, that you never will love art well, till you love what she mirrors more.[1]

<div align="right">JOHN RUSKIN</div>

Nothing can last for ever, and the great age of British watercolour drew towards its close by the middle of the nineteenth century. In 1851 Turner died. *Sic gloria transit*. There are many other wonderful painters to look at and rejoice in. Some painted in this country and many in other countries too. Nothing, however, can quite match the galaxy of talent which we enjoyed in that one great century of British watercolour. These men left us more than great paintings; they left us a great tradition, which is recognized and valued by lovers of beautiful painting throughout the world. We can be proud of the fact that we have professional watercolourists still today who keep that tradition bright.

In September 1848 three gifted young art students, John Everett Millais (1829–1896), William Holman Hunt (1827–1910), and Dante Gabriel Rossetti (1828–1882), formed the Pre-Raphaelite Brotherhood and started to paint pictures in a way which differed rather sharply from the style which had become familiar under the existing Art Establishment. They were much criticized. They enlisted support for their own work from Ruskin, the brilliant young critic still at that time in his twenties, and they succeeded in launching a pictorially distinctive movement which lasted until the beginning of the twentieth century.

The so-called Pre-Raphaelites are, I think, the only important art movement in this country to arouse real passion. The fury that these young men excited went beyond the painters; it extended to such a distinguished and mature author as Charles Dickens who described Millais's painting of Christ in the house of his parents as 'mean, odious, revolting and repulsive'. (**48**)

The fury persists today. Writing in *The Times*, Bernard Levin, that cultured, eloquent and generally balanced writer on the modern scene, examined a great retrospective exhibition of their works held only recently at the Tate Gallery. 'The high flown hocus-pocus with which they deceived themselves and with which they are still deceiving multitudes was a false front from behind which there was a group of knowing journeymen posing

as artists.' Mr Levin stressed, to illustrate his point, that the Tate Gallery was crammed at 10 a.m. It's true; I was there.

Any painters who can arouse quite this type of condemnation deserve our attention. The name of the movement is irrelevant. These young men were not Pre- or Post-anything; certainly not Pre-Raphaelite, nor did they for long remain a brotherhood. Each went his own way but all of them painted pictures which can command a fascinated audience even at the present day. Their paintings, besides their technical brilliance, which is great, concentrated on a detailed portrayal of nature, on a brilliance of colour compared with what characterized the oil paintings of their day, and a close relationship with poetry, either their own or someone else's. The increased attention to detail and the sentimentality of the approach, if nothing else, approximated to the style of painting which became prevalent in the Victorian era.

48 *Study for 'Christ in the House of his Parents'*, JOHN EVERETT MILLAIS
The only art movement in this country to arouse real passion

Of the three painters who started the movement, Dante Gabriel Rossetti was the one who made most use of watercolour. Pre-Raphaelite watercolours have a beauty of their own, but are almost indistinguishable from their oils and are sometimes taken to be oil paintings, with disastrous results when cleaning.

What, then, was the style which followed upon the golden age of watercolour, 1750–1850? There were, of course, painters who were trained in the earlier period and who in some degree carried the great tradition forward into the later nineteenth century. William Hunt, one of John Varley's more distinguished pupils, was one of these, as was William Callow (1812–1908).

Nevertheless the verdict on Victorian painting expressed in Martin Hardie's book, though perhaps too harsh as a generalization, is hard to contradict: 'To a large extent the watercolours of the Victorian era reflect the dullness, vulgarity, pretentiousness and self-righteousness of the period.'[2]

The turn of the mid-century marked, after all, a change, with the Great Exhibition, the death of Turner, the formation of the Pre-Raphaelite Brotherhood and the birth of Helen Allingham, one of the most distinguished and popular of the Victorian watercolourists. Two names, Birket Foster and Helen Allingham, can be said to typify the period. Both were able painters, popular in their own age, and their paintings are much in demand today. Mrs Allingham, who was by all accounts a most delightful person, was married to the Irish poet, William Allingham, and one of his poems mirrors the subject-matter of many of her paintings.

Four ducks on a Pond
A blue sky of Spring
White clouds on the wing
What a little thing
To remember for years
To remember with tears.

For myself there is a limit to the number of ducks and small children, to the minute detail of nature and emphasis on local colour, that I can take. I miss the broad sweep of Cotman's washes and the brave flourish of Constable's brush.

Nevertheless from a commercial point of view my judgement would have been wrong. Mr Eric Holder of Abbott and Holder, who have built a substantial business selling pictures by post, recalls that at one time Victorian genre paintings had their own section in the list. 'Soft Centres, Sweet, Sentimental and Sometimes Silly'. Eric Holder reflects that perhaps it was he who was silly since some of these paintings today fetch several hundred times the price he was charging.[3]

The Victorian era marked, then, a change in the style of painting watercolours which not only reflected a desire among painters to experiment with new approaches – e.g. the Pre-Raphaelites – but also responded to a change in the market. There is no doubt that Victorian households demanding watercolours were larger in number than those in the reign of

George III, but they were a different type of household. The new Victorian families favoured furniture that was becoming heavier and more pretentious every year, with a type of decoration that included the addition of new frills and encrustations to demonstrate, as it were, the solidity of their achievement. The watercolours themselves were mounted in garish gold surrounds and in gold frames which did little to enhance the beauty of the works within them. But, as Sickert once observed, 'at least the brutes bought'.

The professionals tended to give them what they wanted. Some of the survivors of an earlier age bowed down in the house of Rimmon at least to the extent of emphasizing the detail and the local colour and laying on the sentiment. Let me confess that there is a brisk demand for Victorian watercolours of this type. They are collectors' items and represent the 'charm school' of the period. There were, however, better things to come.

Nowhere was this better demonstrated than in what came to be known as the Glasgow School. It consisted of painters mainly from Scotland and the North of England, painting in a style which marked a welcome relief from the accepted pattern of Victorian art.

Arthur Melville was born at Loanhead-of-Guthrie, Forfarshire, on 10 April 1855, of humble parentage. At the age of twenty he threw up a job in a grocery business to become an artist, training at the Edinburgh School of Art. His early paintings are rather over-elaborated oils and not remarkable. He obtained, however, enough support to go to study in Paris in 1878. It was here that he discovered that watercolour was his medium. The French students of those days, who thought of watercolour as an English idiosyncrasy and suitable only for ladies, were astonished at what Arthur Melville could do with it (49). His technique is rather special and consisted in preparing paper with coats of Chinese white and painting onto it and then after it had dried adding rich blobs of colour. The result looks very free, almost slapdash, but this disguises the immense care which went into this difficult but effective process. He was a daring, unconventional artist trying things that no one had tried before, associated with the Glasgow School and influential in his day on other painters, notably Frank Brangwyn and probably Hercules Brabazon, of whom more later.

Thomas Collier was born at Glossop in Derbyshire on 12 November 1840 and educated at the Manchester School of Art. He lived rather a tragic life, his first wife and his son both dying young. He exhibited sparingly and sold quite easily at modest prices. He was comfortably off and shared a love of poetry with his second wife. It is tempting to include Thomas Collier almost as an amateur. He was sufficiently well off not to have to sell his paintings and was thus able to enjoy sketching and sell what he painted in his own good time. His paintings are, however, quite delightful and well worth looking for. He was untouched by some of the

49 *Bravo Toro*, ARTHUR MELVILLE
A daring unconventional artist

rather irritating Victorian mannerisms of his day. He painted with a
directness and a simplicity reminiscent of an earlier age.

Joseph 'Creeps' Crawhall (1861–1913), born at Morpeth in Northumber-
land, came from an artistic family. His father was a close friend of Charles
Keene, the illustrator, who used some of his sketches as a basis for
drawings in *Punch*. There is no doubt that Joseph Crawhall intended to
become a professional painter, going to the Studio of Aimé Morot in Paris
to study. It was, I think, his experiences in Paris which turned him into the
kind of delightful artist which he eventually became. His father had
brought him up in the family tradition of drawing from memory, and
judging by his work he must have had a highly developed visual memory as
a result. All this, combined with his natural gifts for recording the quick
impression, somehow failed to match the careful drawing from the model
practised by often less gifted fellow students. He became somewhat
frustrated, concentrated on watercolour and gave up the struggle to

50 *Chinese Goose*, JOSEPH CRAWHALL
A highly developed visual memory

become a professional painter, at any rate in oils (**50**). I do not really know whether he should be regarded as a professional or an inspired amateur in watercolours. It perhaps hardly matters. He was certainly a keen amateur in sporting events. He loved hunting and rode well. To ride a winner was as satisfactory as to paint a picture. For a time he whipped in to a scratch pack of hounds. He painted when in the mood. He painted superbly well and was much admired by fellow artists, not least by the Glasgow School who can, I think, claim him as a member. He spoke little, was much beloved of children, known affectionately as 'Creeps' or 'The Great Silence', painted sometimes on brown holland, despised expensive paraphernalia, used the back of a chair as an easel, admired Whistler and, like him and the Glasgow School, thought little of the accepted wisdom of conventional Victorian art.

He certainly kept the torch of British painting alight during a rather dim period.

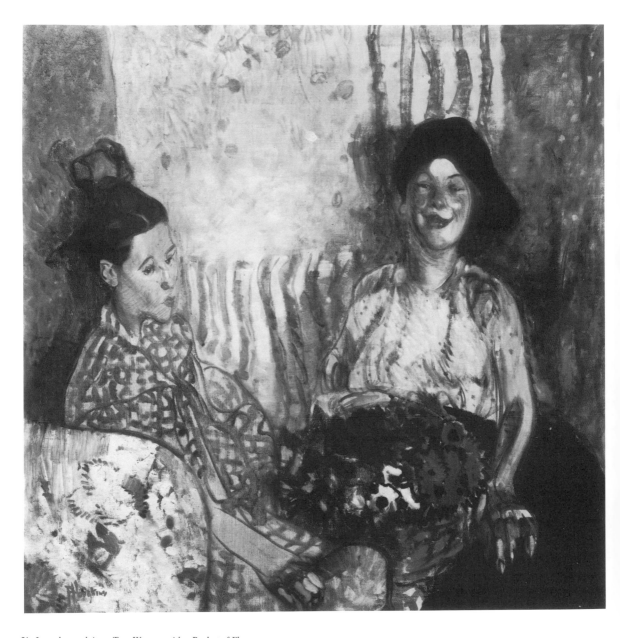

51 *Loveday and Ann: Two Women with a Basket of Flowers*, FRANCES HODGKINS
A beautiful handwriting of her own

The number of women who reached the first rank in British painting as professionals in the art is somewhat limited. Angelica Kauffmann, Dame Laura Knight, Ethel Walker, Helen Allingham, and perhaps the most distinguished of all, Gwen John. One more professional woman water-colourist, however, certainly deserves a mention – Frances Hodgkins (1870–1947) (**51**).

She was born in New Zealand, daughter of a solicitor of artistic and intellectual interests who had emigrated to that country. He taught both his daughters to paint in watercolour. After her father's death and the marriage of her sister she decided to make her life in Europe – Brittany, Holland, Morocco. Somehow the new bright moving images she saw merged with the skills she had learnt with her father painting the bush back home. By 1902 she was settled in Paris teaching watercolour. She showed her paintings at the Société des Aquarellistes. She would probably have stayed there, but the First World War began and she came to England – St Ives in Cornwall, Bridgnorth, eventually Manchester as a successful designer for the Calico Printers Association, a one-man exhibition in London, and membership of the Seven and Five Society, a small group of the best of the younger painters.

She went on always, it seemed, breaking new ground. The master of shapes and colours drawn from New Zealand, Morocco, Paris, the print designs of Manchester, backed with the skills she had shown over so many years, merged in a very beautiful handwriting of her very own. The broken earthenware, the changing shapes, the clear light formed the basis of one of our watercolourists of the first rank. She takes her place half-way through the twentieth century as one of the Pastmasters we should study and from whom we can learn.

The final break from the rather tedious traditions of the Victorian establishment, at least so far as watercolour is concerned, came, however, from a healthy injection into British painting of external influences. Wilson Steer (1860–1942) was the son of a portrait painter and was twenty-two years of age when he failed to gain admission to the Academy Schools. Instead he went to Paris. The impact of the Impressionists he met upon the talents which he possessed was everything that could be wished for (**30**).

Finally, no account of the nineteenth- and twentieth-century painters in watercolour could fail to include the names of two Americans – John Singer Sargent (1856–1925) and James Whistler (1834–1903). Sargent was the most fashionable portrait-painter of his day. He was, however, more than a fashionable painter. His watercolours, which he really took to painting extensively rather late in his career, influenced a little perhaps by his admiration for the amateur Hercules Brabazon, are indeed remarkable. He handled paint and water with the same confident ability with which he handled oil. He painted watercolour a little perhaps as an escape from the

pressures of his main career, painting for his own amusement and giving paintings to his family and friends. He painted much in Venice, staying with his friends the Curtis family at the Palazzo Barbaro. No watercolourist can look at his work without envy of the skill which he displays (**52**).

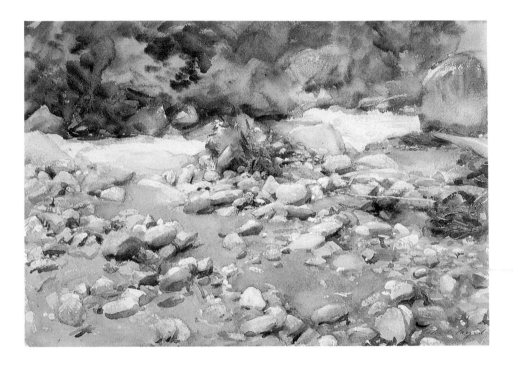

52 *River Bed*, JOHN SINGER SARGENT
Painting for his own amusement

James Whistler was another American who, like Sargent, painted so consistently in Europe that we tend to think of him as a European painter. Trained in Paris, Whistler led the Aesthetic movement in Britain. He argued the case of Art for Art's Sake. For him painting was a matter of pattern, formal arrangements and colour harmony. What matters to us, however, is not perhaps his theories but the beauty of his watercolours. His painting of a mother and child shown here (**53**) is an example of what a real master of the art can do with watercolour. It also perhaps calls into doubt some at least of his artistic theories.

This short account of the past history of the professional painting of watercolour in the United Kingdom demonstrates that it has a place in the history of art which though, perhaps, small is certainly a distinguished one.

We must see it in its context. We owe a debt to the continental painters who preceded us, the drawing masters of Europe who guided our early draughtsmen, to the superb example in landscape of painters like Poussin

53 *Mother and Child*, JAMES WHISTLER
Art for Art's sake

and Claude. We need to remember that in the middle of the eighteenth century, when English watercolour was just getting into its stride, Europe was a storehouse of great painting and still leading the world in the charming and witty twists and turns of the Rococo period. Despite this, and for a period of one hundred years, we can claim to have led the world in this particular art form, and still enjoy a reputation above most others.

We, of course, owe this situation to the painters I have been talking about – to Girtin, to Turner, to Constable and their like – as well as to some brilliant professional painters who followed them. I would, however, claim that without us amateurs all this would have been much more difficult. The amateurs of watercolour in this country have indeed played a most distinguished part in the whole history of its development, more distinguished perhaps than has – at least by the general public – been fully appreciated. It is to their role that I now turn.

Amateurs of the Golden Age

They were, themselves, a kind of contemplative cattle, and flock of the field, who merely liked being out of doors, and brought as much painted fresh air as they could back into the house with them.[1]

JOHN RUSKIN

Both Martin Hardie and Iolo Williams in their works on British water-colour give considerable attention to the work of amateurs. In Martin Hardie's book the view is expressed that for practical purposes the subject of amateurs can really be confined to the period between 1750 and 1850. In broad terms the argument can be summed up by saying that before 1750 they had no paint and after 1850 they had no time. This particular opinion is, I feel, open to question. Nevertheless there are some powerful supporting arguments for it.

In the early years professional tuition would have been largely confined to London or to Bath. In the latter part of the nineteenth century men became more engrossed in the problems of making money or in administration or in politics. It is argued that these occupations were inimical to the practice of the arts. The professionals themselves were organizing institutions for exhibiting their paintings which in the main excluded amateurs. Wealth was more widely distributed. Finally, and I find rather convincingly, it is argued that Ruskin's enthusiasm for turning the teaching of art and drawing into an examination subject was in itself sufficient to deal the death-blow to the amateur. The amateur needs by definition to love something, and men do not love examinations.

And yet amateurs had certain advantages which sustained them and enabled them to make a varied but substantial contribution to art throughout the whole period of its development.

Perhaps the most important asset that the amateur enjoyed was indifference to the market. He did not have to find a buyer for his work; he could draw and paint to amuse himself, being free to innovate if he felt so inclined or free to recall the paintings of an earlier age, if he was so minded. Iolo Williams holds the view that, in general, amateurs do tend to look backward in their work which often gives the impression of being painted a generation earlier than it was. This can, of course, be at times an immense advantage. Nevertheless, I would rate indifference to public opinion as the outstanding advantage of the amateur.

Let me at this point re-emphasize that the gap between the amateur and the professional is not and never has been very wide. There are, and thank goodness for it, plenty of professionals who show an indifference to public opinion. Every new style of painting involves at some point an original and hitherto untried approach. These innovators, whether professional or amateur, are the people who carry the torch of painting forward. Do not imagine that in the novelty of their approach they draw their art from nowhere. Nearly every man owes something to the past, amateurs perhaps more than most. It is in the synthesis of all they know and have seen that is to be found their own special contribution to the art. Sickert, who was Whistler's pupil, remembered that Whistler liked to claim complete originality for everything. As Sickert once observed, 'He could never understand that it was no shame to be born.'

Let us start then with the Pioneers. John White, whenever he was born, was painting actively between 1577 and 1590. He can be regarded either as a colonial governor who happened to paint or as a painter who happened to become a colonial governor. Explorer, seaman, adventurer, he was an Elizabethan and a man of his time. One must, I think, accept Laurence Binyon's judgement of him that he was not a professional painter but had received training from some professional artists. He was in a way the first of the amateurs in both England and America.

He accompanied Sir Walter Raleigh on some of his voyages. His paintings were known and copied in prints in America but the originals only came to light here in 1865 when the library of Lord Charlemont, an Irish peer, was sold at Sotheby's in that year. The library included a volume of drawings and watercolours, 'The pictures of sundry things collected and counterfeited according to the truth in the voyage made by Sir Walter Raleigh, Knight, for the discovery of La Virginca in the 27th yeare of the most happy reigne of our Souveraigne Lady Queene Elizabeth and in the year of Our Lord God 1585.'

These adventurers when they landed had found themselves amid sur-roundings which exceeded the most sanguine hopes of those to whom they reported. Woods and shrubs sweeping down to the sea shore. Vines heavy with grapes trailing the ground. Abundant game, friendly inhabitants.

The story of the hopes, the disappointments and the eventual failure of this mission are not for this book. It fell, however, to John White to depict the scene in what are among the earliest English watercolours that we know (**54**). Drawing and painting from life, he shows in his own direct style the plants, fruits, birds and fishes which he saw. From the paintings included in the collection it would seem likely that John White must have gone also with Frobisher on his voyage seeking the North-West Passage.

He returned to Virginia as Governor of the new settlement where his daughter gave birth to the first child of English blood born in North

One of their Religious men

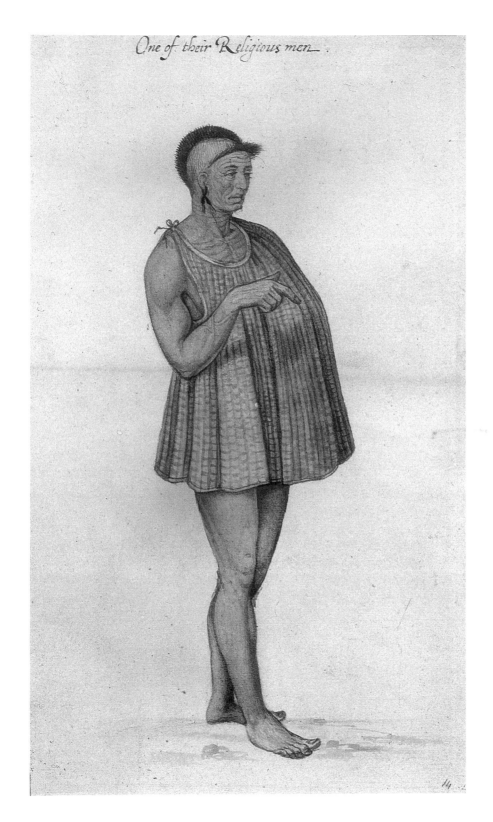

14

54 *Indian Religious Man*, JOHN WHITE
Among the first of the amateurs

So beering vpp to the holones ffleat with forty Saile of Shipes and cominge vpp with them
the fight begin againe very hot one both sides but wee had not ingaged aboute one heure but the
an vnluckey shot that came from the holones and comeing through ouer Shipe fire hit me one the
kneen of my ham one the Right lege it striking me lame for the present but I prayse the Lord it
was spent bee fore it hit me or elsse it woud haue caried my leg away but it did me no greate
adoe but a small hurt with splinters of the ship the Dockter for bid not much let my leg swormg
if that I coud not goe so that I was fort to goe downe amongest the woonded men where one Laye with
out a leg one another with out an arme one wounded to death one another groning much payne
and beging and me vnder one in one manes and another in a nother which was a sad sight to see men
men thus slautred with the treacherey of ouer owne nation and them who liued at whom at ease
and wanted nothing but gouger to sett there ouer nation flower but forseing what the douls being in
a popestie pearle and sending the true harterd subjectes to fight agenst a Trade sorte but sensured
and spending our derossett blod for our king and contreys honour not this king it is much to spend ouer
Liues for the aduance and liberty of our cuntrey whilst our owne trabourd cuntrey men can sit at
hom eating and drinking the fat of the land and rejoyeing at ouer ouerthrow so fighting all that day
with less strenth let no less ouder which made the Dutch to woder at our corage yet wee Lost the
shipes ofter for wee wer too much ouer yeardes with strenth for the had more then twis the shipes wee
had yet wee burnt two or three of there shipes with the fire ship wee had and the Day sittene there
was two of there shipes burnt by there owne fire so hauing spent all the Day and night wee come
wee feast for the second Dayes and meeting that night the next morning our generall cominge a
Councell of war and ouer heaue shipes being wery much torne and disabled: hauing Lost a greate
of men pretaded to make a Retreate too neader ouer owne cost and it being Nindey and the wind garing
wee made an Easey saile to neader ouer own cost and the holones fleat folowing vs with all the saile
the coast for that morning the had a fresh Squadron of shipes come to there Eid from the cost of holand

55 *Mounk*, EDWARD BARLOW
'Deserves to be set in a ring of gold'

America, Virginia Dare. Later he returned to England and eventually retired to Raleigh's estates in Ireland where he died.

John White was the forerunner of many a naval painter. William Hodges (1744–1797) accompanied Captain Cook, Augustus Earle and Conrad Martens were with Darwin on the *Beagle*. Before the age of photography we were largely dependent upon the pens and pencils of such men to describe the emerging glories of the New World which were being opened up before our eyes.

Edward Barlow (1642–1703) must certainly rank not only as one of the earliest but also as one of the most exciting of the English watercolourists. Born at Prestwick in Manchester on 6 March 1642, he was the son of a farmer. Despite every attempt to persuade him otherwise, he ran away to sea. 'I would not stay in Lankishire which was my natif contrey.'

From then on he served either as an able seaman in the Navy or in the Merchant Navy. In 1660 he was in the *Royal Charles*, the ship which brought Charles II back to England at the Restoration. In 1661 he was serving under Lord Sandwich against the Barbary pirates. In 1665 he was fighting against the Dutch at the battle of Lowestoft. His journal features a spirited and ambitious drawing of *The English and Duch ffletes* and particularly of the *Royal Charles*, the *Royal Prince*, and the *Royal James*. In the Dutch fleet we see Captain James Opdams blown up. In 1772 Barlow was captured by the Dutch in the Straits of Banca and imprisoned in Batavia. It is to this event that we owe the Journal which he continued later as a diary. It starts with his leaving home in his best clothes and his mother 'beekinnins her hand' as she calls him back, and continues with an illustrated account of his life at sea.

He lived a life packed with danger and adventure. The French were attacking the merchant fleet in European waters and pirates like Captain Kidd and Captain Avery were attacking it further afield. He encountered violent storms, death, disease; men, women and children bought and sold in the slave markets of the East. He became an experienced and able seaman and navigator. He was a man who could not suffer fools or knaves gladly and some of his captains fell into both categories. He served as first mate in an East Indiaman at £5 a month and acted as Captain for a time on the *Septer*, belonging to the East India Company. (The post went later to another man with less experience who mistook the Bristol Channel for the English Channel, ran the ship aground and lost her.) There were pickings to be got from carrying private cargo and Barlow made enough money to retire at the age of sixty-one. Always he wrote and drew. He drew people, ports, animals, fishes, but above all he drew ships which he knew and understood. Painting the *Monk*, he writes: 'A ship which deserves to be set in a ring of gold for the good service she has done . . . and she shall have my good word so long as she is a ship'. (**55**)

Maybe at times his drawing and painting are a little rough. He did not belong to the polite world of Wenceslaus Hollar. He was, however, a brave man, a fine seaman and a courageous amateur painter.

Francis Place (1647–1728) was almost a contemporary of Edward Barlow but born in very different circumstances and living a very different kind of life. The youngest son of Rowland Place of Dimsdale in Yorkshire, he was trained as a lawyer and went to London with the intention, at least his father's intention, of following that career. His heart, however, was not in it; he preferred the arts, and London undergoing an outbreak of the plague held few attractions other than his friendship with Wenceslaus Hollar which must have further encouraged his artistic leanings.

In the event he gave up the law, returned to Yorkshire and concentrated on drawing, etching, experimenting in making porcelain and fishing. Concentrated is perhaps too strong a word. Francis Place must have been an altogether delightful man but he never really concentrated on anything. He started with the aim of being a professional. He was employed by the print-makers on a number of projects. At one moment he was asked to paint all the ships of Charles II but gave up from impatience at the drudgery. He married twice and his second wife, Widey Wilkinson, brought him sufficient means to relax and enjoy his life as an amateur of nearly everything. He had a happy time meeting his friends in York who included Henry Gyles, the glass-painter, William Lodge, another amateur painter and etcher, Thomas Kirke, FRS, Martin Lister, FRS, John Lambert of Calton Hall, another amateur, and Sir Ralph Cole, Bt, MP for Durham, amateur painter and patron of the arts. He was indeed a very gifted man and his paintings provided at least part of the bridge between the topographical draughtsmen and the true landscape painters who were to follow (56).

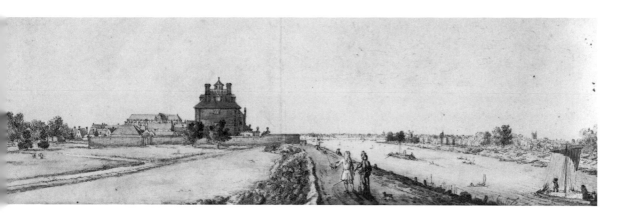

56 *Peterborough House from Millbank*, FRANCIS PLACE
An Englishman whom it is worth while to remember

He travelled widely in Britain at a time when travel was none too easy and his paintings include examples from his journeys in both Wales and Ireland. It was said of him that he was an Englishman whom it is worth while to remember, not among the famous men, but among men furnished with ability who did their share of the work and passed on the torch.

Men like Francis Place were battling against the odds in producing their drawings in the seventeenth century. Paint was of poor quality. Travel was arduous and difficult. General interest and support, though it was there, was much more limited than that which grew into existence later.

Hollar, to whom we have already referred, made his living as an etcher, and Francis Place in his early years had some pretensions to do the same. The process involved was drawing on copper through a wax ground and letting acid cut the lines that would transfer the image from the copper to the paper. It was relatively simple and rapid, and it was much adopted by amateurs, including such men as Francis Barlow and William Lodge, Francis Place's amateur friend from York.

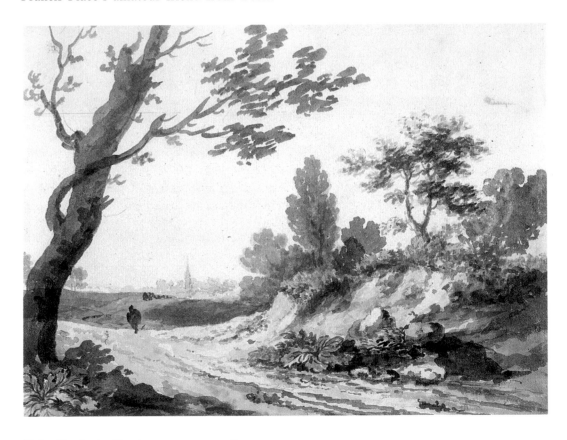

57 *Road Leading to a Church*, WILLIAM TAVERNER
Relying on nature rather than topography

Born at the very beginning of the eighteenth century during Francis Place's lifetime, William Taverner (1703–1772) provides for the amateurs a kind of bridge between the centuries. He was a lawyer following his father as a Proctor in the Doctors Commons. He came from an artistic family and developed a remarkable ability in the painting of landscape – itself something of a novelty at the time in which he lived. He attracted the attention of Smollett who warmly praised his gifts and was noted for a 'wonderful genius' by George Vertue in his notebooks. He was clearly influenced by continental paintings which he must have seen, but his most interesting and outstanding work is in landscape painted direct from nature. I reproduce one of them here (**57**). Drawing and painting freely with the brush, relying on nature rather than topography for his effect, this brilliant amateur, born at the very beginning of the eighteenth century, was leaping forward into another age. He was in every sense a pioneer.

The eighteenth century was above all the age of the amateur, in art, in architecture, in landscape gardening, in science, in chemistry. Men of ample means, well educated and widely travelled, often in control of superb houses and huge parklands and estates, had adequate scope to exercise their patronage and display their talents.

Typical of the age was William Ponsonby, later the second Earl of Bessborough. Born in 1704, collector of works by Claude, Poussin, Raphael, Salvator Rosa and Van Eyck, he was the patron of Jean Eteime Liotard, the celebrated Swiss painter. His son, the third Earl, inherited many of his father's tastes and was himself an amateur painter. I have seen a painting by him of Chatsworth, which was the home of both his mother and his sister-in-law. He was married to the beautiful and celebrated Henrietta Frances Spencer, and his daughter Lady Caroline Lamb is remembered mainly for her tempestuous love affair with Lord Byron. For the record, she was also an amateur painter.

These, then, were the forerunners of the century so richly endowed in painters, patrons and pupils that was to follow.

It so happens that in the field of watercolour painting they were matched by the emergence of the quite remarkably gifted group of professional painters who were to earn the great reputation which this nation now possesses in that particular field of art. The combination was a huge success. The amateurs eagerly sought the services of their professional colleagues to instruct them and very often their families in the art of drawing and painting.

It was, of course, a very different world from that of today. Social and financial differences were wider. Both the penalties of poverty and the benefits of riches were much greater. The cushion of social security was absent and the high levels of taxation which now prevail were non-existent. Any one of us today finding himself translated by some time machine into

the eighteenth century would feel a certain shock. Nevertheless, if one wanted the conditions for a great upsurge of artistic talent, this was it. Nor in the main did the patrons and the painters find it unacceptable.

Some painters accompanied their patrons on foreign tours which they would otherwise not have managed to arrange. Some painters even used the sketches the amateurs made in the course of foreign travel as a basis for paintings of their own.

Some of the amateurs, and there were a very large number of them in this period, painted very well, but reflecting upon the period as a whole it must be admitted that the furtherance of the art of watercolour during these years depended far less on how the amateurs painted and far more upon the fact that they were there, providing a broad and admiring audience for the substantial number of capable professionals around. Before 1750 the amateur shared to the full the task of pioneering the growth of landscape painting in the United Kingdom. After 1850 a number of very able amateurs, drawing partly on lessons from the past, kept, as we shall see, something of the glory of those years before us in a period when the general standards of the art may be thought to have declined. Here in the middle and most glorious period of watercolour their general influence, their taste, their experience and knowledge of the continental scene and their sheer love of painting were perhaps far more important than any paintings of their own.

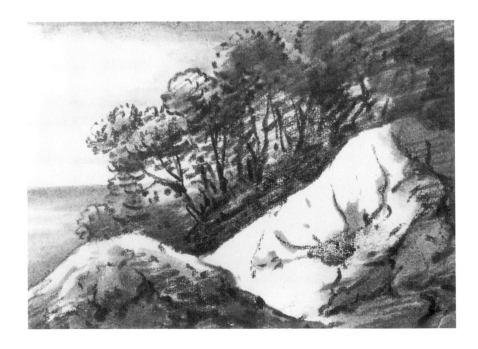

58 *Landscape near Fetcham*,
DR THOMAS MONRO
A catalyst for other painters

Against this background it would seem to be wise to consider one or two of those amateur painters whose influence was greatest in the painting of their time, not so much through their skill in execution but by the parts they played and the reputations they enjoyed amongst their fellow artists. There were many such, but I will concentrate on two.

Dr Monro (1759–1833) occupies an outstanding position in the field of British watercolour. He was in a remarkable way a catalyst of painters, helping them to bring out their gifts, to influence one another and to emerge into the masters of the art which he had somehow divined that they were. In addition he did much quietly to succour and sustain them when sickness or disaster came their way. His father, too, was a well-known doctor and he inherited considerable means, good taste and a large collection of books. He became a collector and patron of the arts. Never himself without paper, charcoal and Indian ink, he made hundreds of sketches around Fetcham in Surrey and appears to have been influenced by Gainsborough whom he probably knew (**58**).

Keen amateur though he was, his real fame stems not from his own paintings, but from a kind of academy which he established in his home to which a considerable range of young painters, who later became famous, were invited. He drove his family at times near to desperation as his young artist guests were quite a lively lot. He did not teach them. He let them copy his paintings. Sometimes one would draw and another colour the copies. Dr Monro appears to have kept and preserved the resultant work.

Sometimes the young men were paid. Tom Girtin and Turner sat at desks opposite one another. They appear to have got 3s 6d and supper for their pains. Expert researchers find some difficulty in sorting out the precise events at this academy and who painted there when it was at Bedford Terrace or later at 8 Adelphi Terrace. What matters, however, is not the detail but the undoubted fact that this situation actually existed. A doctor who was an amateur painter was providing the launching pad for some of the most famous painters that this country can lay claim to.

Another man of influence in this period was Sir George Harland Beaumont (1753–1827), friend and patron of Constable, famous in the history of British art and letters – baronet, landowner, educated at Eton and New College, Oxford, rich, a gifted artist, full of wit and controversy. Here was a man who in many ways typified the eighteenth-century amateur.

While at school his teacher was Alexander Cozens. His holidays included sketching holidays in Norfolk with Woollett, the engraver, Thomas Hearne, the painter who became a lifelong friend, and his most understanding tutor, Mr Davy. At Oxford he came under the influence of a remarkable teacher named John Malchair, whose skill as an instructor was to influence a large number of amateurs of this period.

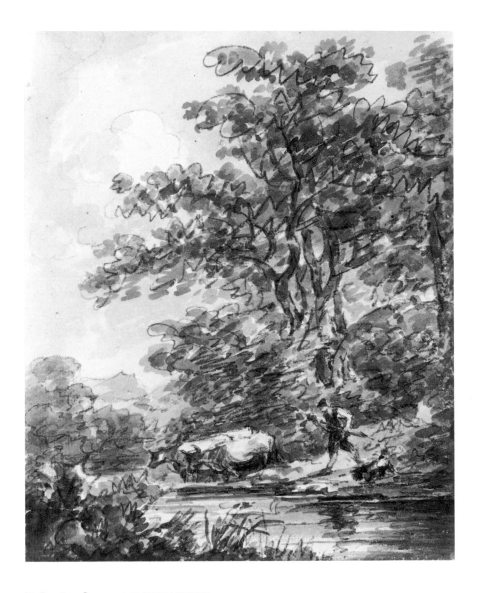

59 *Crossing a Stream*, GEORGE BEAUMONT
'A man whom nature had designed for a great painter'

He married in 1778 and in 1782 set off with his wife for a tour in Italy which was to be of importance in his artistic life. During it he met John Robert Cozens, the son of his old drawing master, who certainly helped him and exercised some influence upon his technique.

He became a Member of Parliament for the rotten borough of Bere Alston in 1790, and his life might well have developed along the pattern of public and private responsibilities common to men of his position in that age. Fortunately for many painters and for the world of art generally, he

abandoned the political scene in 1796 and devoted himself to his estates and to his real role as a patron and collector.

Up to this point his situation differed little from that of many another of his contemporaries. What distinguished George Beaumont from the others was the extraordinary sensitivity and generosity of his character. The list of those he helped is itself formidable – William Alexander, George Arnold, William Collins, John Constable, J. R. Cozens, Samuel Daniell, Harry Eldridge, and many others. It was his manner of helping which was outstanding. He would go out of his way to place a commission to help a needy painter. He welcomed at his table at Coleorton men as varied in class and background as Lord Lonsdale and John Constable, and seems to have treated them all with the same delightful informality. On seeing a good painting by Sir David Wilkie, RA, in an impetuous moment of generosity he presented him with one of his most precious possessions – the maulstick which had belonged to William Hogarth.

His interest was painting and with him it was a subject which happily transcended all problems of class or wealth or background. All he asked of his friends was that they should share his pleasure and enthusiasm for the subject, and he used his wealth to help with great tact and discernment either them or sometimes their widows in any way he could. His greatest pride was that the dramatist, Francis Beaumont, was an ancestor and had lived at Grace Dieu among the rocks of Charnwood close to Coleorton.

He lived in a sense artistically between two worlds, admiring the classical paintings of the past and encouraging Constable to copy his Claude landscapes, while thrilled by the new interpretation that Constable and his friends were bringing into their adventurous watercolours. His standing in the world of art was high though not at times uncontroversial. At the end of his life he was influential in establishing the National Gallery to which his own small but important collection passed upon his death.

He was with all this a good amateur painter in both oils and watercolours (59). As Wilkie once described him, 'a man whom nature had designed for a great painter but whom high fortune had marred'. Substitute for 'high fortune' the hard struggle of our lives in earning our living and pursuing our chosen path in life, and it would be an epitaph that many amateurs might well adopt.

These then were the varied types of men who provided the backcloth to the great age of watercolour. They were by no means unique. Almost every professional watercolourist of note found himself at some stage in close relationship with those who owned the great houses and wide estates of the eighteenth century. Constable's early connections were with Sir George Beaumont and later with Bishop John Fisher, one-time tutor of Prince Edward. Through Fisher, Constable found himself in touch with the Bishop's nephew, John Fisher, and these three men exercised a consider-

able influence on Constable's career. Paul Sandby was linked with Colonel Gravett, Charles Greville and the Earl of Harcourt. Harcourt made no bones about the advantage to a painter of contacts in the right quarters and wrote to his friend: 'Fools honour title and fortune and everyone else is obliged to have some outward respect for them. . . . Let me recommend you to cultivate, though not in a mean manner, the acquaintance of as many as you can.'

Paul Sandby, who could almost be regarded as the father of British watercolour, was not slow to take his advice.

Turner's closest friend and patron was Walter Fawkes of Farnley Hall, who bought, collected and showed his paintings. Girtin was with Lord Lascelles at Harewood Hall and had Amelia Long, daughter of that prominent collector, Sir Abraham Hume, as a pupil. J. R. Cozens was helped in old age by both George Beaumont and Dr Monro. Alexander Cozens was the friend and confidant of William Beckford. John Crome was very close to Thomas Harvey, the amateur and collector. John Sell Cotman painted some of his finest work while staying with Mrs Cholmeley at Brandsly Hall and was also much helped by Dawson Turner, the Yarmouth banker. John Varley was helped, housed and highly regarded by Edward, Viscount Lascelles, to whom he had been introduced by Dr Monro.

Thus the landscape watercolourists found themselves entertained in the great houses and on friendly terms with the great families of the time in much the same way as these houses had become open to the noted portrait painters of the day. There was, however, an important difference. Few amateurs could seriously contemplate attempting to follow in the footsteps of Lely or of Gainsborough. Landscape painting was different. It was nearer to what most of them had anyway been taught in their schoolrooms. These new painters were ready to teach them and their children something of the art of drawing and painting the glories of the countryside which lay about them. They all moved happily, or most of them happily, together to the painting years which lay ahead.

The years between 1750 and 1800 were in the nature of an overture to the great achievements which centred about the turn of the century. Some amateurs were learning to draw under the wise guidance of Malchair at Oxford. Girtin and Turner were sitting opposite to one another at Dr Monro's home, copying his watercolours and being somewhat resented by Mrs Monro for the noise and confusion they created. Sir George Beaumont and many of his friends were undertaking the Grand Tour and gaining information from the paintings they saw and the new and wonderful scenery through which they travelled. Paul Sandby was learning to etch in Scotland and encouraging William Reeve to mix more honey with his paint to alter and improve the texture of the dry cakes which at that time were all that was on offer to the English watercolourist.

Small wonder then that in the period immediately preceding and for some time following 1750 the majority of pictures were in monochrome and that etching was much in vogue. Etching was used not only for depicting landscapes but for the accurate presentation of antiquities and other purposes in an age when the advantages of photography were not available. David Alexander recently (1983) assembled a number of these etchings by amateurs and displayed an interesting collection at Wolfson College, Oxford.

Examples of the work of some of the amateurs of the period shown in this exhibition read at times like the pages of *Debrett*. One volume of prints, mainly by amateurs, and described as 'A Collection of Prints engraved by various Persons of Quality' printed at the Strawberry Hill Press, is now in the Walpole Library, Farmington. It contains some 120 prints of work done in the second half of the eighteenth century. Another pair of albums, now in the British Museum, includes work by over 150 amateurs. The first volume concentrates principally on prints by women and the second on prints by men. These volumes and David Alexander's exhibition and catalogue illustrate vividly the sheer volume of amateur activity which was being generated during this period. It is impossible to do more than illustrate a little of the wealth of varied talent that existed at this time.

The Marquis of Townshend (1724–1807) was a highly talented amateur caricaturist. He used pen and ink rather than watercolour, which, as I have pointed out, presented many technical difficulties. His drawing of the then Duke of Norfolk well illustrates his talents (**60**).

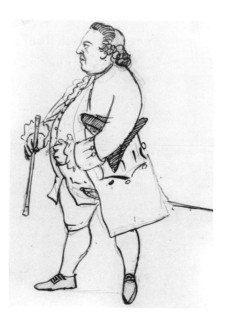

60 *Duke of Norfolk*,
MARQUIS OF TOWNSHEND
Like the pages of *Debrett*

Of all the amateurs who attempted caricatures of the social or political scene, Henry Bunbury was perhaps the most outstanding (**61**). His talent emerged as a schoolboy at Westminster and was developed as an undergraduate at Cambridge. He made designs for the professional engravers who may not always have improved his work.

Among the women amateurs Amelia Long, Lady Farnborough (1762–1837) was one of the most distinguished (**62**). Perhaps the most fascinating must have been Catherine Maria Fanshawe (1763–1834) (**63**) who was not only a painter but a poetess. She moved in the circle of Madame de Staël and Lord Byron and attended a lecture by Sydney Smith which she made the subject of one of her poems.

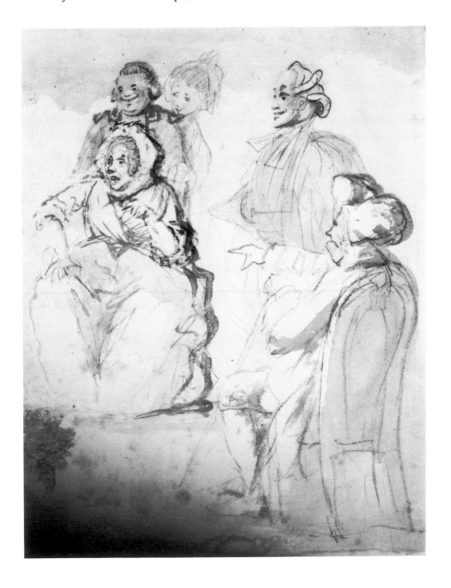

61 Sketch for 'Reading the Will', HENRY BUNBURY
A gifted caricaturist

62 *Near Duxford, Cambridgeshire*, AMELIA LONG, LADY FARNBOROUGH
Pupil of Girtin

63 *Plan of Campaign*, CATHERINE MARIA FANSHAWE
Painter and poetess

An amateur of the period of a more down-market background and of considerable influence upon the approach to painting at that time was the Rev. William Gilpin (1724–1784), who undertook tours and made drawings and etchings to illustrate the beauties of the countryside, then only just beginning to be appreciated (**64**). He wrote books both on the art of etching and on landscape. His illustrations were etchings prepared from his own sketches. His text reads sometimes rather oddly and was indeed ridiculed years later by Rowlandson who published *Dr Syntax's Tours* with his own illustrations.

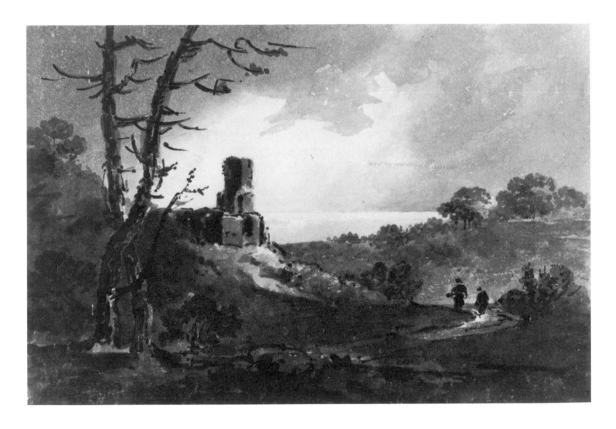

64 *Two Figures by a Lake*, REV. WILLIAM GILPIN
Student of the picturesque

True, today the discussion of what is beautiful and what is picturesque may seem a little dated, and a philosophical debate as to whether a cow is more picturesque than a horse seems scarcely relevant. Nevertheless, it would be wrong to minimize the effect that Gilpin had in the age in which he wrote. English landscape had been almost unnoticed before the time of Hollar and of Francis Place. Gilpin argued the case for landscape as a pictorial subject. What he said then was new. He carried forward the torch

lit by Hollar and Place and prepared or helped to prepare the public for the appreciation of Cotman, Constable, Girtin and Turner who were to reach their prime a few years later. Once again we see the interlocking roles of the amateur and the professional.

The West Country made a notable contribution to English watercolour during the eighteenth century. A number of amateurs were painting in this area and four deserve mention. Coplestone Warne Bampfylde (1720–1791), squire of Hestercombe in Somerset, was born twenty years before Francis Towne. His monument in Kingston Parish Church records that he possessed a distinguished taste for the fine arts, genuine wit and a sound judgement. He was an honorary exhibitor at the Society of Artists and at the rather less distinguished Free Society. He also showed at the Royal Academy. These exhibits were probably in oils and Bampfylde joins a distinguished list of men who set out to paint in oils and are remembered for their watercolours. He was quite a good caricaturist but is more noted for his landscapes. Some of his best were painted at Stourhead, the home of his friend Henry Hoare.

Francis Towne (1740–1816) (47), already mentioned as a professional painter, was born at Exeter and painted mainly for a local market. Another unremembered oil painter whose outstanding watercolours only came to light in about 1920, he also supported himself by giving drawing lessons, mainly to local amateurs.

Among his pupils was John White Abbott of Exeter (1763–1851), an 'apothecary' and surgeon of Exeter. White Abbott never travelled abroad, devoted himself to his medical practice in Exeter and spent as much time as he could at his painting upon which he was still actively engaged at the age of eighty-two. A certain Parson Patch once said that Abbott had been so extolled and admired at Exeter that he was content with copying himself. His paintings resemble to some extent those of his teacher, Francis Towne. He is, however, in his own right an outstanding artist. He is at his best when he paints his vision of his local woodland folk and woodland scenery through the eyes of the countryman and doctor that he was (65).

Born twenty years later than White Abbott in the neighbouring county of Dorset, John Bavestock Knight was an amateur in the full eighteenth-century tradition. A typical country squire of his time, six feet six in height, handsome, well dressed, managing estates for the Duke of Bedford, mistaken for the Duke when riding in his company, and with a wife and a family of eight children, he dominated the local scene. We know from his letters that he painted and copied paintings extensively in oils, but it is once again his watercolours that have survived. He probably saw paintings by Francis Towne and White Abbott in the local houses, but he travelled widely and his work shows the influence of John Robert Cozens and in some degree of Cotman.

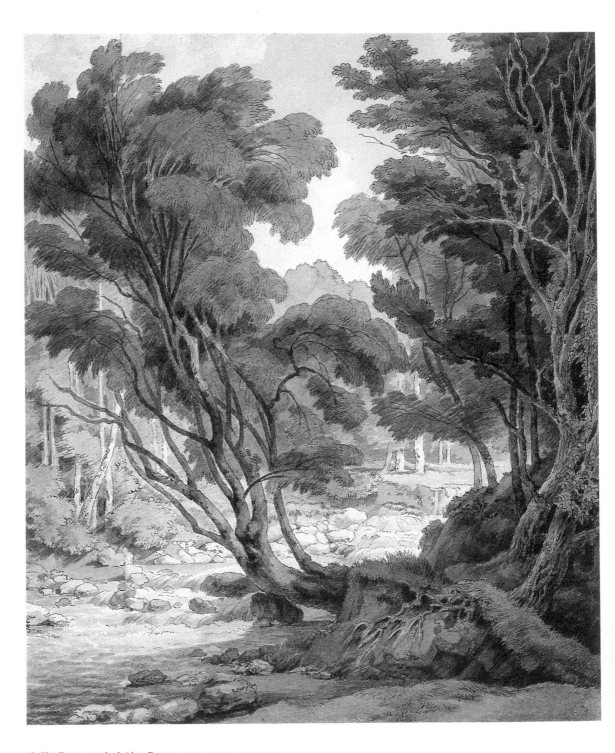

65 *The Erme, near Ivybridge, Devon*, JOHN WHITE ABBOTT
Painting his own vision of his woodland scenery

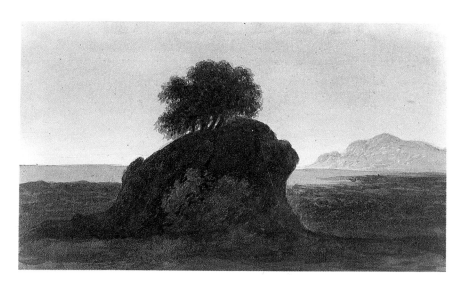

66 Landscape, FRANCIS TOMLINE
A charming small watercolour landscape

Though the West Country made a notable contribution during this period there were of course large numbers of amateurs painting in every part of the British Isles. Among them were Amos Green and his wife. Amos Green (1735–1807) was born at Halesowen and was a professional painter, mostly of flowers. The landscape watercolours painted by him and his wife fall into a different category. They are both regarded as amateurs who painted some fine watercolours of the Lake District and formed a remarkable duo.

Many of the amateurs of this as of other periods were pupils of distinguished painters and often came to paint in a manner which closely resembled that of their teacher. It is probable and in some cases almost certain that some of the work of such amateurs has over the years come to be attributed to the master and the name of the amateur has sunk into oblivion. Frances Tomline was a pupil of John Glover (1767–1849). John Glover was of humble origin, the son of poor parents, disabled by a club foot and working in the fields as a boy. He became in time a distinguished painter of English landscape and a popular teacher. Iolo Williams lists Henry Salt (1780–1827), James Holworthy (1781–1841), Henry C. Alpert and George Pickering (1794–1857) among his pupils and notes that all of them, including his son William Glover, showed a close fidelity to his style. Frances Tomline was no exception and appears to have painted to a consistently high standard. I illustrate from her sketchbook a charming small watercolour landscape which is in my possession (**66**). It is attributed of course to Frances Tomline but could have been quite easily attributed to John Glover.

A number of the eighteenth-century amateurs are well documented but the probability is that many, if not most, of them who painted between 1750 and 1850 have gone unrecorded. Amateur paintings tended to be kept within the families of those who painted them. Sometimes these paintings have survived, and still today one finds new groups of such paintings often of high quality finding their way on to the market. A recent instance was the case of William George Jennings (1763–1854). He lived and painted in the middle of the great age of British watercolour. Practically nothing survives to document his life save a miniature by Shelley and a substantial number of paintings, together with a delightful sketchbook, which have all been preserved by his descendants in the Addenbrooke family of Cambridgeshire. A number of these paintings, oil sketches and watercolours, were put on sale at the Krios Gallery in 1981 and examples of his work are now fairly widely distributed (**68**). I have three in my possession.

He was, of course, a contemporary of Constable and appears to have been a fairly close friend. He exhibited at the Royal Academy between 1797 and 1806 but seems to have had neither the need nor wish to sell his paintings.

Constable was always happy to leave his paintings in the hands of amateurs who appreciated them. He apparently gave Jennings one or two as gifts and Jennings also purchased from Constable. He also stayed at one of Constable's houses, Albany Cottage, on Hampstead Heath. It seems probable that they painted on occasion together, and it is certain that Constable exercised a considerable influence over the work of his older amateur friend.

The paintings have created quite an interest among students of the work of Constable and of his family and friends. They are indeed quite delightful and anyone today who feels he cannot quite afford the price of a Constable could do much worse than acquire a painting by this follower and devoted admirer.

Another so far unrecorded amateur of this great period was Margaret Matilda Pell (1816–1856), eldest daughter and second child of Sir Albert Pell, an eminent medical practitioner, and his wife Margaret Matilda St John. Her younger sister married Alexander Pym and was an ancestor of Francis Pym, MP, the well-known Conservative politician.

Margaret Pell, known as Minny by her family, was an accomplished artist. Like Jennings, she painted exclusively in this country. Some record of her skills and activities has been left in the *Reminiscences* of her brother, Albert Pell, who records that she was often the sketching companion, though not it appears the pupil, of David Cox, painting with him in the open air.

In his *Diary* her brother, Oliver Claude Pell, records that 'Minny drew uncommonly well having learned miniature painting from Miss Kendrick

and sketching in watercolours from Copley Fielding.' Writing of her painting tours, he remarks, 'Minny on these occasions drew a great deal being generally out all day.' Many drawings exist done by her at Swanage and also on the summer excursions in Wales, Scotland, Ireland and Devonshire (69). It was a great worry to her if she did not succeed as well as she fancied, though very often the best of her drawings proved to be those with which at the time she was least pleased. Minny also had lessons from De Wint. The different styles in her painting may reflect the variety of distinguished painters with whom she associated.

Apart from exhibiting some of her work in aid of a fund for victims of the Crimean War, she never sold or, as far as we know, exhibited her pictures. These exhibits and indeed her painting generally attracted favourable comment in *The Times*. Her paintings are still held within her family.

The two famous names of the period are both men – the Earl of Aylesford and Dr William Crotch.

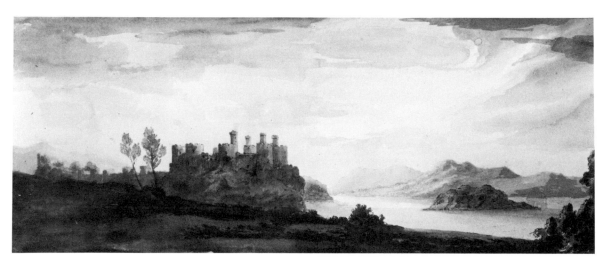

67 *Conway Castle*, EARL OF AYLESFORD
One of the great eighteenth-century amateurs

Practically everyone connected with the Earl of Aylesford seems to have painted. A gift for painting may or may not be hereditary, but there are certainly families like the Varleys who seem to include a large number of artists. But in truth even the local clergy were affected. The Rev. William Price (1753–1822), Rector of Allesley, a few miles from the Aylesford house, was himself an accomplished amateur. It must have been a pleasant atmosphere at the Aylesford family home, Packington in Warwickshire. The Earl of Aylesford was indeed one of the great eighteenth-century amateurs, coming early under the influence of Malchair at Oxford, making the Grand Tour, interesting himself in politics, but not too much, excelling

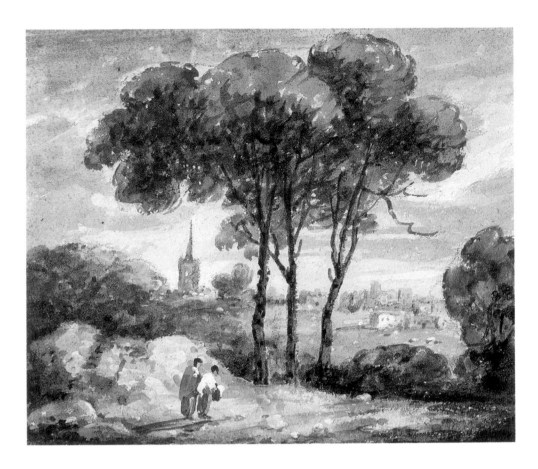

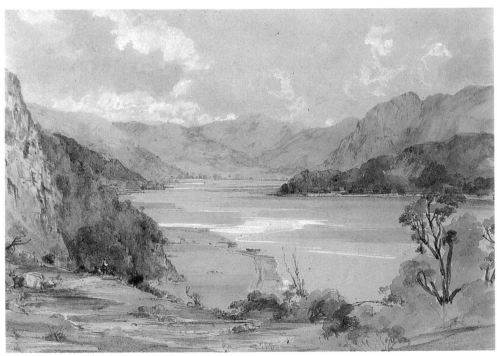

in archery, a skilled ivory carver and turner, an amateur of architecture, building an original church at Packington, an experienced etcher. He was an enthusiast and a very able one in anything to which he turned his hand. His wife, and daughter Frances, drew and painted exquisite studies of flowers, moths and butterflies. The main body of his work – which records his travels, mostly in England and Wales – is contained in bound volumes and remains in the hands of his family, still living at his home in Packington. The church he built and the house he lived in stand in the Park where deer still safely graze. They are surrounded by the industrial Midlands but are a reminder of a more tranquil age. It was in such hospitable conditions that I was given the opportunity to select a painting for reproduction in this book (**67**). The fourth Earl of Aylesford demonstrated very well all that the eighteenth century had to offer.

Left above: 68 *A View of Highgate from Hampstead Heath*,
WILLIAM GEORGE JENNINGS
Friend of Constable

Left below: 69 *Landscape*, MINNY PELL
Lessons from De Wint

Right: 70 *Dr Crotch playing Mozart*, JOHN CONSTABLE
A good contribution to amateur art

Dr William Crotch (1775–1847) survived being a musical prodigy. At two years and two months he could pick out 'God Save the Queen' on the organ and at two years and seven months he made his first public appearance. At three and a half he had a Royal Performance at Buckingham House. By the age of fifteen he appears to have escaped the round of concerts and he became organist at Christ Church, Oxford. It was here that he came to know and later to comfort and care for Dr Malchair. Basically Dr Crotch's life was in music and he later became the first Principal of the Royal Academy of Music.

With it all, William Crotch had to paint. Malchair may well have been his early inspiration, but William Crotch developed the style of Malchair only after Malchair had lost his sight. He painted scenes of London and also of Hampstead, later to be painted by Constable, who was his friend and whose drawing of Dr Crotch playing Mozart will make a good final contribution to the amateur art of this period (**70**).

The Continuing Tradition

From the beginning amateurs have figured notably in the history of English watercolour, often using the medium with distinction, and occasionally having an important share in its artistic development.[1]

IOLO WILLIAMS

The amateurs who painted in the second half of the nineteenth century faced a situation quite different from that confronting their forebears a generation earlier. Martin Hardie, in volume III of *Water-Colour Painting in Britain*, is right to emphasize the difference in their situation. The role of patron was more widely spread among the emerging Victorian middle class. Tastes were changing, not altogether for the better. Above all, there was no longer a recognizable school of painting to which to refer.

Not surprisingly, the style adopted by these amateurs was as varied as the styles adopted by their professional counterparts.

These later amateurs were as gifted as any that preceded them. Perhaps an even higher proportion of their paintings are still held in the hands of their families and there must, as always, be many such amateurs whose work is totally unknown. I choose a small number to illustrate the amateur painting of the period. Naturally quite a number of amateurs at this time painted in general conformity with the pattern of Victorian painting of the period, but many were rather excitingly nonconformist.

Perhaps the most accomplished was Mildred Anne Butler (1858–1941) (**75**). Her watercolours first appeared in the Dudley Gallery in 1888 and she exhibited regularly at the Royal Academy and the Old Water Colour Society and in Ireland. She was, I suppose, the most professional amateur that I have yet referred to and must be one of the few amateurs admitted to full membership of the Royal Watercolour Society. Yet amateur she was. Painting was in no sense her career. It was her pastime but one in which she set out to be fully competent. To this end she worked with a number of artists including Paul Jacob Naftel and William Frank Calderon. For a time she studied under Norman Garstin and was much influenced by Stanhope Forbes. She was the daughter of an accomplished amateur painter, Captain Henry Butler, and lived all her life at Kilmurry, set in the heart of the Kilkenny countryside. The beauty of an Irish garden and Irish pastures are reflected in her paintings. Born in the same decade as Helen Allingham

and painting in a similar way, she achieved a standard which was not markedly inferior to that of Helen Allingham herself.

Another painter of this period was George James Howard, later Earl of Carlisle (1843–1911). He was a man who took his painting seriously and was one of the rare amateurs who used the techniques and adopted something of the approach to painting of the Pre-Raphaelites. He was strongly influenced by Ruskin. His wife Rosalind, a daughter of Lord Stanley of Alderley, was an outstanding Radical of her day, supporting Irish Home Rule and the cause of the Boers in the South African War. Amid all this she ran the estate rather well and gave time for her husband to paint. After his death she carried out a suggestion of his and transferred much of the Castle Howard collection of paintings to the National Gallery.

Another painter who deserves a special mention is Augustus Hare, not so much for the quality of his watercolours as for his devotion to the art and for the encouragement he gave to other amateurs. He was of course the well-known travel writer. Intended for a career in the church and brought up by an austere guardian, his earlier work is in ink and wash only, as she did not permit the use of watercolour.

Somerset Maugham, who knew him in his old age and stayed with him from time to time, wrote a brilliant account of this remarkable and fascinating man in his book of essays, *The Vagrant Mood*. It is worth reading not only for its account of Augustus Hare but also for its picture of the world of Edwardian house parties and the atmosphere in which their pastimes such as painting were conducted. One of Augustus Hare's books was *The Story of Two Noble Lives*, an account of the lives of two sisters, Lady Waterford and Lady Canning. It is to Lady Waterford as a watercolourist that I now turn.

It seems to me that the most interesting contribution of those who painted after 1850 was that a number of them, ignoring the example of the professionals, ignoring public demand and indifferent to the conventional wisdom of the artistic establishment of the day, painted quite differently in order to please themselves.

Among the best and earliest in point of time of these amateurs was Lady Waterford (1818–1891). Louisa Anne, second daughter of Lord and Lady Stuart of Rothesay, was born at the British Embassy in Paris. Her father was Ambassador to France in 1816–1824 and 1828–1830. She passed much of her childhood in France. Her mother, who was a talented amateur artist herself, encouraged her two daughters. The elder later became Lady Canning. In 1842, Louisa Anne married, somewhat against the wishes of her family, Henry, Lord Waterford, a member of the Beresford family, well known and much admired in southern Ireland. Henry was famous at Melton where he had once brought a horse into the dining-room and jumped him over a five-bar gate facing into the fire for a wager of one

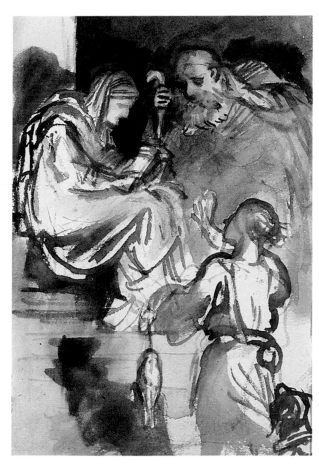

71 *Study for a Mural*, LADY WATERFORD
Among the small group of outstanding amateurs

Below: 72 *The Pink Palace*, HERCULES BRABAZON
One of our great watercolourists

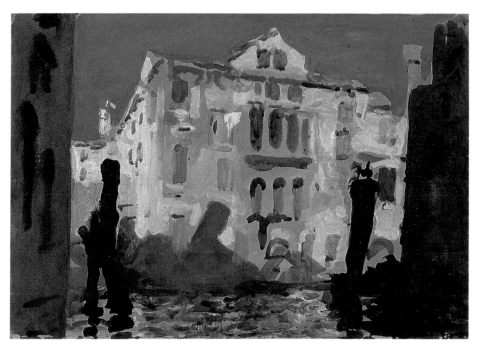

hundred guineas. His life seems mainly to have been in the hunting field where he was killed in an accidental fall in 1859. There were no children of the marriage and on his death his widow went to live in Ford Castle on her late husband's Scottish estates. During all this she painted – children, religious paintings, frescoes on the walls of the school at Ford. She was herself both deeply religious and of an intellectual turn of mind. She knew both Ruskin and Burne-Jones. Ruskin thought a lot of her and probably did more harm than good to her painting which was in a style different from his. She was a good colourist and at her best painted with a dash and freedom which make her works recognizable. She summed up Ruskin very well: 'he is the reverse of the man I like and yet his intellectual part is quite my ideal'. She must, I think, have been very good for him. Lady Waterford's paintings are not numerous but well worth searching for. I would certainly rank her among the small group of outstanding amateurs of the second half of the nineteenth century (**71**).

Born three years after Lady Waterford but living and painting into the twentieth century was the most famous amateur of them all. Hercules Brabazon (1821–1906), second son of Hercules Sharp, was educated at Harrow, Geneva and Cambridge, where he read Maths. He determined, despite parental doubts, to become a painter, and he most gloriously succeeded. He spent three years in Rome studying under J. D'Egrille in 1847 and later under A. D. Fripp. On the death of his elder brother and later of his father, he inherited estates in Ireland and England. On this he assumed the name of Brabazon. He left the running of his estates to his brother-in-law and to his nephew. For his own part, he spent his summers in England and his winters in France, Spain, Italy and Germany. After 1867 he included North Africa, the Nile and India in his travels. In 1891, at the age of seventy, this consummate amateur, who had never sought to sell or to exhibit any of his paintings, was elected to the New English Art Club and persuaded by John Sargent and others to allow a Brabazon Exhibition to be mounted at the Goupil Gallery. The catalogue carried an introduction by Sargent, then at the height of his fame, which included this passage:

The gift of colour, together with an exquisite sensitiveness to the impressions of nature, has been the constant incentive, and the immunity from picture making has gone far to keep perception delicate and execution convincing. Each sketch is a new delight of harmony and the harmonies are immeasurable and unexpected. Taken by nature or rather imposed by her.

The exhibition was an immediate and resounding success. The years that led up to it and the paintings which marked his progress deserve close study by any painter in watercolour, whether amateur or professional. Hercules Brabazon was never a sportsman, never took much interest in the affairs of

the countryside, but devoted his life to painting. He was the friend and confidant of other painters. He travelled in France with Ruskin, where they sketched the same subjects together, once at least at Amiens, where Brabazon was accompanied by his nephew, Harvey Combe, and Ruskin by Arthur Severn. Brabazon pondered much upon art, read many books, copied the works of other artists. It was indeed his frequent practice to copy the works of artists whom he admired. These included importantly Velasquez and Turner. He was, in addition to his painting, an accomplished pianist, who practised for hours on end to perfect his playing. He died at the age of eighty-four full of years and honour.

Some years after his death, his paintings were put *en masse* and somewhat incautiously upon the market – the prices naturally slumped. He got the reputation of being a prolific artist, and his delightful copies of other paintings earned him the gibe of being a copyist. Despite all this, his work lives today, an outstanding contribution to the practice of watercolour in the United Kingdom.

Hercules Brabazon was to my mind probably the most exciting watercolourist of the second half of the nineteenth century (**72**). He towered above most of his contemporaries, whether amateur or professional. His technique employed fairly free use of body-colour and his paintings are reminiscent of Constable sketching freely with oil on paper or of J. M. W. Turner in his late and glorious period of almost abstract watercolour. He painted with a kind of delighted abandon his own impression of the beauty of the world about him, without, I think, caring very much what anybody might think of the resultant painting.

There is something utterly unselfconscious about the best of his work, the uncluttered statement of truth as sometimes seen a little in the painting of a child yet married to a mastery of colour not seen since the greatest days of English watercolour. This man was one of our great watercolourists – so great that he certainly deeply inspired considerable painters like Sargent who were his contemporaries. Look for his paintings, for in them you will find a vision, a courage and a simplicity which have the makings of great art.

Robert Graham Dryden Alexander (1875–1945) married Effie Fletcher, a pupil of Hercules Brabazon who exercised a strong influence on his painting. He falls within my definition of an amateur only because his father chose for him a career in the City to which he loyally adhered. In all else he was a painter. Educated in painting at the Hornsey School of Art and later at the Slade where he had the good fortune to learn from Professor Tonks, the celebrated Principal of the Slade School, he settled at Brentwood and painted delightful watercolours of the surrounding countryside (**10**). In his lifetime he was widely exhibited. A skill beyond the reach of most of us but what an example for us all.

Left above: 73 *Landscape,
Northumberland*,
LORD NORTHBOURNE
Reminiscent of the eighteenth
century

Left below: 74 *The Pewsey
Vale*, RUPERT BUTLER
Painted the Wiltshire
countryside

75 *Woman Sketching*,
MILDRED ANNE BUTLER
The beauty of an Irish garden

Sir William Eden (1849–1915), father of Anthony Eden the prime minister and later first Earl of Avon, was a distinguished painter in watercolours, exhibiting at the Royal Institute, the Dudley Gallery, the New English Art Club and the Salon, Champs de Mer, Paris, a friend of Sickert and an outstanding amateur. He painted in the same period as Hercules Brabazon and was a painter of the same distinction. He was, however, a man of a very different type. Whereas Brabazon, apart from his devotion to playing the piano, gave himself almost wholly to the task of painting watercolours, William Eden was an amateur of almost everything, resembling more closely the amateurs of a century before (**1**). He hunted, shot, boxed, drove, travelled, gardened. He did everything extremely well. He was also very easily exasperated and a well-written and sympathetic account of his troubles real or imaginary was written by his son Timothy Eden, *The Tribulations of a Baronet*.

His views on everything were both original and challenging. The trouble with gardens, he claimed, were the flowers. His views on painting were no exception. 'I'll tell you what is wrong with Venice; Sargent Sunshine and the Salute – that's what's wrong with Venice.' He was a close friend of Sickert and shared with him a deep distrust of the Victorian artistic establishment. He may not have been an easy character and picked some quarrels, notably with Whistler who was by no means an easy character himself.

Eden somehow combined all these activities and his capacity for indignation with the painting of a whole series of beautiful and sensitive watercolours, sometimes of his family and friends, sometimes of landscape and often of interiors. He well illustrates my theme that during the latter half of the nineteenth century it was the amateurs as much as anyone else who kept the torch of British painting alight.

The amateur tradition has been carried on throughout the twentieth century. Indeed the problem which confronts anyone who seeks to give some account of their work is the number of such painters who could be referred to and the high quality of much of their work.

A family which might in some ways be taken to illustrate and represent these later amateurs is that of the Northbournes of Northbourne in Kent. Walter James, later third Baron Northbourne (1869–1932), was both a Lieutenant in the RNVR and a trustee of the Wallace Collection. In *Who's Who* he described himself quite simply as an artist, which he certainly was. He devoted himself to his art and his attitude to painting and to painters was reminiscent of the great amateurs of the eighteenth and early nineteenth centuries which we considered earlier (**73**). A close friend of Tonks, he lost no opportunity of making contact with the art world of his day, entertaining them and sharing ideas and experiences with them. He was himself an accomplished painter in watercolours, but perhaps even more interestingly he was a superb draughtsman, as his etchings, still held mainly by his family, undoubtedly confirm. His son, the fourth Baron, inherited many of his father's talents, had the benefit of training at the Slade and exhibited successfully at the Walker Gallery. His grandson, the fifth Baron, is my own contemporary and we have both shared some happy evenings at art school even if neither of us quite matches up to his ancestors.

During a long life in which he suffered always from indifferent health, Rupert Butler (1886–1973) developed a remarkable skill in the painting of watercolours and he must be counted among the first rank of the amateurs of the period. Educated privately and later at University College, Oxford, he became a firm friend of the Slade Professor of Art, Sir Charles Holmes. He does not, however, appear to have had any formal training. An admirer of Edward Seago, his technique though exclusively in watercolour appears

to have included the same approach through preliminary outdoor sketches, since he painted almost always from notes made in sketchbooks. Some of these sketchbooks happily survive with his colour notes included in them. There is also a small sketchbook of his pen and ink drawings which demonstrate his very considerable talent as a draughtsman. He made his finished pictures in the studio where he managed to retain much of the freshness of his original impression. He spent some period of his youth in Canada and later settled in Wiltshire in the Pewsey Vale and painted mainly that countryside which he knew so well, with an occasional visit to Scotland where he often painted with his friend Wycliffe Egginton. He exhibited his work, which is still mainly in the hands of the family, only rarely, but the paintings are of considerable quality, not least those of the Wiltshire countryside, one of which I reproduce here (**74**).

This account, then, carries the story of the amateurs into the twentieth century. With very few exceptions necessitated by the theme of this book I have omitted reference to contemporary painters. There are too many and we are perhaps too close to them for detailed comment. The amateur would, however, be well advised to study for himself the examples of contemporary painting which are readily available to him. Visits to art galleries, provincial as well as in London, will prove immensely rewarding. The standard of painting is high and the styles and approaches to the art as varied as ever. It is my hope that what I have written about some of the professionals and the amateurs who have contributed to the history of British watercolour will at least encourage amateurs like myself to look for them. A list of Museums and Art Galleries is included in this book and gives some help in finding them. There is no greater source of inspiration to a painter than the sight of other artists' paintings.

Distinguished Amateurs

For practice of the hand doth speedily instruct the minde, and strongly confirms the memory beyond anything else, nor think it any disgrace unto you, since in other countries it is the practice of Princes.

HARRY PEACHAM

There have been many distinguished amateurs and we will examine some of their work presently. In doing so it is also good to remember that painting is a pastime shared and enjoyed by every section of society. Indeed one of the delights of painting is to find oneself involved in a community of men and women of every age, background and occupation who possess a common and absorbing interest.

People who share a determination to draw and paint find themselves for the most part so absorbed in the problems involved that differences between them tend to become matters of secondary importance.

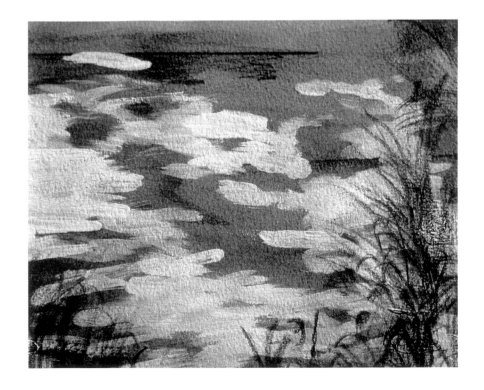

76 *Melting Ice*,
CAROLYN JAMES
A blind painter

Right: 77 *Magnolia*,
WINSTON CHURCHILL
A moment of quietness

It is good for those of us who are reasonably fit and well to remember those who paint despite crippling handicaps. People find a way to paint if necessary with their teeth or with their toes. People even paint when they are blind.

An example of the work in this field is an organisation called Conquest, the Society for Art for the Physically Handicapped started by Mrs Ursula Hulme in 1978 and now boasting two hundred members. This Society stemmed, as much else that is good has stemmed, from classes in occupational therapy. Those amateurs who find painting difficult could do worse than consider the paintings of Mr Ken Biggleston, who holds his brush in his teeth, or the work of Carolyn James, a blind artist who yet continues to produce paintings which delight all who see them (**76**). We have already mentioned that courage is a quality always useful for a painter.

Amateurs of painting are therefore to be found in every section of society. Among the handicapped, among statesmen, among members of the Royal Family.

The outstanding amateur painter of our generation was Winston Churchill. I had the great privilege of serving in his Government and the opportunity of enjoying something of his company. Indeed, he gave me the chance of succeeding in the career of politics which I had adopted. I remember in very early days, when after the war he was leading the Conservative Opposition, how he gave me both encouragement and opportunity.

Once when the Conservatives were moving a vote of censure in the Commons he called me in from the back benches to make the final speech for my party from the despatch box. At the time this was an unusual privilege. Shortly before I rose to speak I went at his request to see him in his room. 'I want you to know,' he said, 'why I have put you up to make the final speech in this debate. I have put you up as an insult to Herbert Morrison.' Working with Winston was just sheer delight. Above all it was fun. I only once saw him painting, and that was after dinner one night at Chequers. He was, I remember, engaged on a huge painting in which a cannon was pointing away from the viewer towards the horizon. It was a painting which clearly presented enormous technical difficulties by which Winston was quite unmoved. His views on painting were set out in his book, *Painting as a Pastime*. In his inimitable prose he sets out the case for the amateur. He was forty when he started. It was a trying time for him in 1915. He had left the Admiralty but remained a member of the War Council. 'In his own words he knew everything but could do nothing. With no great department to administer he suddenly found time on his hands; and it hung sad and heavy. It was during those months of gloom and despair that Winston first discovered the charm of painting.'[1]

He started as many others have started, experimenting with a child's paintbox, and once started he painted through it all, learning as he went, influenced deeply by the Impressionists whom he much admired. 'Learn,' he said, 'enough of the language in your prime to open this new literature in your age.'[2] How right he was. The painting that I reproduce of a magnolia flower picked with his own hands from his window at Chartwell says, I think, something about him in a moment of quietness sàlvaged from the turmoil of the world in which he lived so bravely. It is of course in oils. Winston did not really paint in watercolour. It is the only possible thing that can be said against him! (**77**)

The most distinguished and some of the most interesting amateurs are to be found among members of the Royal Family. I mentioned earlier how Wenceslaus Hollar, one of the earliest of the landscape painters in this country, was employed to teach drawing to the boy who eventually became King Charles II. It may be that this early interest inspired Charles II to re-embark upon the building up of the Royal Collection which had suffered severe losses during the period of the Commonwealth. Though there is no record of paintings by Charles himself, many other members of the Royal Family have been accomplished amateurs as well as patrons of the arts.

78 *Installation of a Weapon on a Ship*, PRINCE RUPERT
A Leonardo touch

Among the earliest and most accomplished draughtsmen in the royal circle we must certainly include Prince Rupert. Remembered from our schooldays as a cavalry leader of distinction and acknowledged as a skilled and enthusiastic sailor, it is not always appreciated that he had considerable ability with a pen. His drawing of the installation of a weapon on a ship has something of a Leonardo touch about it (**78**).

A number of works of art by members of the Royal Family were shown in Windsor Castle in 1977. This exhibition with some additions was later shown in the State Rooms of Hartlebury Castle.

Whilst most heads of the Royal Family added in some way to the Royal Collection and operated in general as principal patrons of the arts, it was George III who probably established royalty most firmly in the world of visual art. In 1764 the *London Chronicle* published an anonymous letter from Rome containing the following passage: 'The fine Arts, hitherto much neglected in England seem now to rise from oblivion under the reign of a monarch, who has the taste to perceive their claims, and a propensity to grant his Royal protection to whatever can embellish human life.'

The King's association with Lord Bute inclined him to a wide under-standing and love of the arts. In youth he received lessons in architecture from William Chambers, in perspective from Joshua Kirby and in drawing from Joseph Groupy and George Michael Moser. The drawings resulting from these studies indicate the Prince's interest and enthusiasm. He was, moreover, much more than an amateur painter. He was fascinated with the problems of design, whether of houses or of furniture, and his taste, much influenced by his knowledge of European art and architecture, was of a high order. In 1770 Matthew Boulton reported that William Chambers, the King's architect, 'is making me a drawing from a sketch of the King's design for a better foot to our four branched vase'.

The illustration I have chosen shows the plan and elevation of a cottage designed by the King for one of his workmen named Bradley which was erected in Windsor Park (**79**).

In paintings there may at times be some doubt as to how much should be attributed to the royal painter and how much to the teacher, but George III was certainly adept enough to be able to communicate by drawing what his wishes were for the design of any object that he desired.

Here was a man who in many ways typified the age of the amateur so widely represented among his subjects. Queen Charlotte herself was not particularly proficient in the arts, but went to great pains to ensure that her children had every chance to develop their talents in this field. They were taught by some of the painters who were patronized by the Court.

Alexander Cozens (1700–1786), who was the drawing master at Eton, instructed the King's growing family. Gainsborough (1727–1788) is said to have painted oil sketches of landscapes for his lessons with Princess Mary, and in the winter of 1786–1787 the Princess Royal arranged classes for drawing and painting at Buckingham House in which she worked together with her sisters and friends. The princesses were also amateur engravers and Queen Charlotte set up a printing press at Frogmore House where their plates were printed. Some of their engravings are included in the Bull Volumes of prints by distinguished amateurs in the British Museum.

79 *Design for a Cottage*,
GEORGE III
Fascinated with the problems
of design

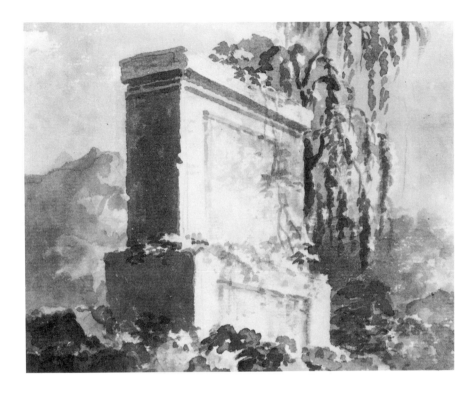

80 *Landscape*,
PRINCESS ELIZABETH
The most artistic of the King's
children

The Princess Elizabeth, the third of the six daughters of George III, later to marry the Landgravine of Hesse-Hombourg, was probably the most artistic of the King's children, not only painting with skill but actually designing several of the garden buildings at Frogmore (**80**).

Queen Victoria herself was among the most prolific and in many ways the most interesting of the royal watercolourists. Her painting activities have been brilliantly described by Marina Warner in her book *Queen Victoria's Sketchbook*. Queen Victoria certainly inherited not inconsiderable talents and drew and painted with obvious enjoyment. She was trained as a child by Richard Westall, RA, and as was the practice in those days, encouraged to copy drawings by her tutor.

All her life the Queen never missed an opportunity to improve her drawing and her painting. She was a serious student of the art of watercolour as well as a competent amateur. Around 1846 she was taking instruction from William Leighton Leitch who had been introduced to the Court by Lady Canning. Leitch, who was himself an accomplished artist, greatly increased the Queen's basic technical knowledge of watercolour and the use of colour tone and composition in painting. The Queen was always ready to draw on the knowledge of other painters and learnt much from such men as Sir Edwin Landseer and Edward Lear.

Victoria

IR del

Designed & Etched by Queen Victoria and given to Anna Maria Duchess of Bedford by Her Majesty
Windsor Castle August 1841

Above: 81 *Vicky, 1841*,
QUEEN VICTORIA

Below: 82 *Victoria*,
QUEEN VICTORIA
Some charming unaffected
aspects of a royal household

Queen Victoria painted virtually all her life. The main body of her work, particularly after the death of Prince Albert, consisted of landscape sketches. The Queen varied her technique, sometimes using body-colour and sometimes painting in pure watercolour. A painting of Balmoral under snow painted in the latter technique and making full use of the white paper only slightly touched with shadow shows very considerable talent (**85**). Her early sketches of her children, her family and friends are often quite delightful. To my way of thinking, they form the best part of what she did,

as well as opening to us an insight into some charming, unaffected aspects of a royal household. I reproduce here two examples of this aspect of her work. One a drawing from the Royal Collection (**81**), and one an etching presented by the Queen to her friend and lady-in-waiting, the Duchess of Bedford, which still hangs in the room in which Queen Victoria slept on her visits to Woburn (**82**).

Prince Albert, who shared in so many interests of the Queen, shared happily in these artistic activities as well. His pen and ink drawings of the family, in particular, show considerable skill.

What is sometimes forgotten is that Queen Victoria's children inherited something at least of these gifts. Victoria, drawn so lovingly by her mother as a child, became a gifted painter. Her copy in pen and ink, watercolour and body-colour of Holbein's portrait of a Hanseatic merchant was sold recently at Sotheby's (**83**). This was painted when the Princess had become Queen of Prussia and Empress of Germany. The Princess Louise, third daughter of Queen Victoria, was another gifted watercolourist (**84**).

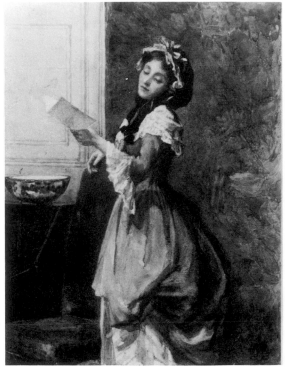

83 *Hanseatic Merchant, after Holbein*, PRINCESS VICTORIA
Queen Victoria's children inherited her gift

84 *Reminiscences*, PRINCESS LOUISE
Another gifted watercolourist

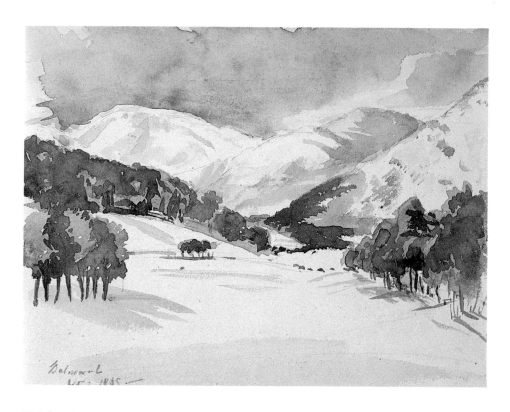

85 *Balmoral under Snow*, QUEEN VICTORIA
Painted nearly all her life

86 *Broadlands*, PRINCE CHARLES
Continuing a royal tradition

Lady Canning, the sister of Lady Waterford – already referred to as one of our most distinguished watercolourists – was responsible for introducing Leighton Leitch to the Queen, and was herself an accomplished painter. A lady-in-waiting to Queen Victoria, she married Lord Canning, son of the Foreign Secretary and later Viceroy of India during the Indian Mutiny. Lady Canning's paintings of India are as interesting as were her personal letters to Queen Victoria during the time of the Mutiny. Her watercolours represent not only the many watercolours painted by members of the royal household but also the great body of amateur work executed by English men and women stationed in India.

During the following reign, Queen Alexandra brought to England a very special talent for painting watercolour, and a number not only of her paintings but of her sketchbooks are held in the Royal Library at Windsor.

The tradition of royal painting, and in particular an interest in watercolour, continues today with His Royal Highness Prince Charles, who inherits considerable skills from both sides of his family, devoting much of such limited spare time as he has to study of the art, and who has developed his talent to become, as the example in this book shows, an accomplished performer (**86**).

I have thought it right to mention some of these painters if only to illustrate that neither physical handicap, nor the cares of statesmanship nor the burden and responsibility imposed on royalty have provided a barrier to men and women in their enthusiasm for painting. The paintbrush can be an ally to us all.

The Drawing Masters

Yesterday begin my wife to learn of one Browne, which Mr Hill helps her to, and by her beginning, upon some eyes, I think she will do very fine things, and I shall take great delight in it. [1]

SAMUEL PEPYS

We have already seen how many of the professional painters of the British School devoted their time and skill to the teaching of amateurs. The position of the 'Drawing Master' has indeed been an important one in the history of British art.

In early days, at any rate before 1700, the teachers of drawing were mostly employed either at Court or in one of the great aristocratic households. Thus Peacham in the reign of James I: 'It is no more disgrace for a Lord to draw a fair picture, than to cut his hawks meat or play at football with his men.'

By 1693 there are records of a school, Christ's Hospital, going to considerable trouble in the selection of a drawing master. The Governors took the trouble to consult Samuel Pepys, and Christopher Wren had given his opinion that 'our natives lack not genius but education in that which is the ffoundation of all Mechanick Arts a practice in designing or drawing to which everybody in Italy Ffrance and the low Countries pretends to more or less'. In any event the practice grew and the post was filled, at least for a time, by Alexander Cozens, later drawing master at Eton College and teacher to the children of George III.

Nor were schools the only institutions to employ drawing masters. The Royal Military Academy, responsible as it was for the training of engineers and gunners for the Army, considered the teaching of drawing landscape an essential part of their military qualifications. No less a man than Paul Sandby served twenty-eight years as Drawing Master to the Academy and in the process gave instruction which, quite apart from any military use, must have laid the foundation for many a soldier amateur painter.

I was myself educated at the Royal Military Academy and can recall, now more than fifty years ago, receiving at least elementary instruction as to how to draw a panorama for the purpose of describing targets for an artillery battery. I was not, alas, taught by Paul Sandby!

Major General Gaspard Le Marchant (1766–1812) was largely instrumental in starting the New Military College at Marlow. He was himself

a keen amateur painter and had he not been killed at the age of forty-six leading a charge at the battle of Salamanca more might have been heard of him as an artist. He had had lessons with William Alexander and also from a famous drawing master, William Payne, who had been appointed to the Royal Military College.

Even David Cox, according to his biographers, spent a year as a uniformed captain teaching at the Staff College, though Martin Hardie casts some doubt upon his exact position. John Constable, though pressed to accept the post of Drawing Master at Marlow, managed to repel the poisoned chalice. In his own words, 'had I accepted the situation offered it would have been a death blow to all my prospects of perfection in the Art I love'.

Be that as it may, the military interest in drawing which was shared also by the Royal Navy produced or at least encouraged a long list of military and naval amateur painters.

Le Marchant, General Napier, and Sir George Bulteel Fisher (1764–1834) stand out among them.

Looking back at the greatest period of British watercolour, the remarkable fact is that the brilliant watercolourists who were painting around the year 1800 were almost as famous for their teaching as they were for their pictures. Alexander Cozens, Paul Sandby, John Varley, Thomas Girtin, John Glover, Francis Nicholson, David Cox, William Payne, and Peter de Wint spent much of their time instructing sometimes young professionals and, often, a host of eager amateurs.

John Varley stands out among this distinguished company, for he taught a whole generation of English artists coming to maturity in the years 1805–1810.

Both Cox and De Wint learnt much from this remarkable man and it is perhaps a tribute to his teaching methods – at least when teaching young professionals – that in later years they painted in styles wholly distinct from those of their early instructor. John Varley was at the same time teaching a host of amateurs. At a guinea an hour these lessons provided him with a reasonable income. Many of these pupils, such as Lady Mary Monck, show the unmistakable imprint of Varley's style. It is indeed a fact that the pupils of many of these distinguished painters often came to form something in the nature of a school representing, and often representing very well, a reflection of their master's style.

By the turn of the century individual amateurs were looking for and obtaining instruction in substantial numbers. The advantages of such tuition from the point of view of the amateur are obvious.

The advantage to the professional painters was not merely the additional income, though that certainly did not come amiss, but the widening of the social circle in which they moved with a corresponding widening of the

market for their paintings. Most painters at this time were therefore keen to find pupils to whom they could impart their knowledge. But some just did not want to know.

Richard Wilson (1714–1782), a close friend of Sandby and a gifted painter, had been invited to a gentleman's house, but when he approached it he turned to an acquaintance and said, 'Are there any young ladies?' He was assured in the affirmative. 'Do they draw?' continued Wilson. The reply was 'Yes'. 'Good morning to you then', said Wilson, and turned away.

Perhaps the most famous teacher of them all was John Malchair (1731–1812). Malchair was born in Cologne, the son of a watchmaker. He was, and this was to be a major influence in his life, extremely musical.

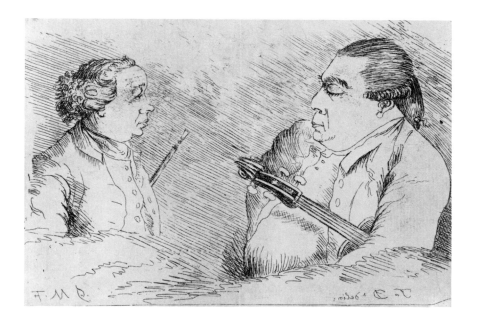

87 *Two Musicians*, JOHN MALCHAIR
'Seeming to learn the art rather than to teach it'

Trained as a singer, he eventually obtained work in London as an orchestral violinist and augmented his slender earnings by teaching both music and drawing, in which he had also developed a considerable gift. Eventually a Mr Robert Price invited him to his home at Foxley in Herefordshire and through his brother-in-law got him a job as leader of the Music Room Band, as it was called in Oxford. This position, which he obtained in 1759 at the age of nearly thirty, was to prove the foundation for his future career. Basically he was a musician, but he continued to teach

both the violin and drawing. He attracted many young Oxford pupils anxious to improve their drawing before undertaking the Grand Tour. He organized sketching parties on foot or by water. He was a remarkable teacher and his interest today lies in the fact that he taught a large number of the amateurs who later became famous during this period. They included John Skippe, Lord Aylesford, Sir George Beaumont, John Gooch (1752–1825), Thomas Frankland (1751–1831) and many others.

His own paintings are certainly of interest; the influence he exerted on his pupils is even more. After one or two abortive starts he managed to write a book on landscape painting with various examples intended for the use of beginners. It is proudly sub-titled 'Rules and Examples for the Drawing of Landscape According to the Practice at Oxford'. His concept of teaching was curiously modern. His advice included such thoughts as the importance of 'drawing like a child while teaching a child' and 'seeming to learn the art rather than to teach it'. (**87**)

The last years of his life proved full of sadness. Some rowdies broke up a concert in which he was playing, when an orange was thrown which broke the better of his two violins – a fine Cremona. He never played again in public. Gradually he lost his sight, making his last drawing in 1798, and was completely blind when he died in 1812 aged eighty-one. It is, however, for the record that one of his colleagues at Oxford, even more famous in music, Dr William Crotch, gave him much comfort in his infirmities.

We amateurs therefore are indebted to a long line of teachers, sometimes in institutions of one sort or another, sometimes giving individual instruction. Sometimes, as we have seen, the amateurs themselves were so remarkable that they influenced other amateurs and even influenced the professionals themselves. There remains one most considerable figure who deserves a mention: John Ruskin (1819–1900).

Ruskin is described as an art critic and a draughtsman. He would, I think, fit into my definition of an amateur. I reproduce a drawing of a Gothic window, a form of architecture which he greatly admired, in Venice, a city with which his name will always be associated (**88**). I refer to him here not simply because in 1869 he was appointed Slade Professor at Oxford and large audiences of young people hung upon his words, but because he was in a much wider sense a teacher. His voluminous writings on almost every subject from architecture to mineralogy, and all treated as a branch of morals, are beyond the capacity of most of us amateurs to read. Yet every amateur of any form of art should try to understand something of what this very great man had to say and to enjoy the supreme beauty of the prose in which he said it. Perhaps the best approach is to see him through the eyes of those who understand, even if they do not always agree with, the vision that he had.

Two books can be thoroughly recommended for this task: Kenneth

Clark's *Ruskin Today* and Jan Morris's edited edition of Ruskin's *Stones of Venice*. I give a short quotation from each so that you can get the flavour. First Kenneth Clark writing of the decline in Ruskin's reputation.[2]

From Wordsworth to Proust there was hardly a distinguished man of letters who did not admire him. Austere critics like Leslie Stephen believed him to be one of the unassailable masters of English Prose and, on the death of Tennyson, Gladstone (whom he habitually insulted) wished to make him Poet Laureate, and was only prevented from doing so by the fact that he was out of his mind.

Then Jan Morris in her Introduction to Ruskin's book, *The Stones of Venice:*

It concerns the sanctity of labour, a concept far ahead of its times. Ruskin reasons that the best of architecture, like civilisation itself, depends upon the creative participation of ordinary people in its construction. In an era when the average English workman was hardly more than a mechanism himself, Ruskin was reading into the nature of Gothic the text of a time when every man used his heart, his head and his brain in the divine glory.[3]

The drawing masters, then, from the humblest, struggling for a living, to the great princes of the world of art education, have handed on the torch of knowledge to their pupils. From Wenceslaus Hollar holding his hand over his defective eye as he taught the future Charles II to the Slade Professors of the modern world, we, the amateurs, should be grateful to them.

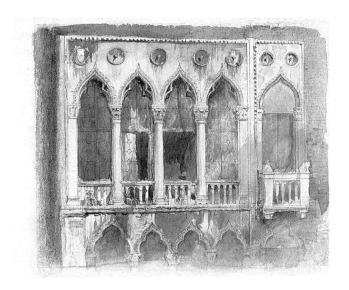

88 *Gothic Window, Venice*, JOHN RUSKIN
In a much wider sense a teacher

The Companionship of Painting

And I desire, that the reader should note this, in closing the work through which we have passed together . . . that the following of beauty brought him always under a sterner dominion of mysterious law; that brightness was continually based upon obedience and all majesty only another form of submission.[1]

JOHN RUSKIN

We have discussed the pleasures of being an amateur and the ways in which he can learn to draw and to paint, and have taken a look at what other men, professionals or amateurs, have achieved in the field of watercolour. Certainly the happy amateur is he who has studied and learnt the disciplines which contain the practice of the art which he has chosen. Yet for the amateur painting is not just hard work.

Ruskin's admonitions should be taken with a grain of salt. Henry James, reflecting on Ruskin's book, *Mornings in Florence*, expressed it rather well: 'One may read many pages of Ruskin without getting a hint of this delightful truth; a hint of the not unimportant fact that art, after all, is made for us and not we for art.'[2]

The important thing is to enjoy painting. Look at the way Villiers David, an able contemporary amateur, has painted the view from his bedroom window (**89**). The cat, the curtains, the children in the park, are all entering into the spirit of it. Amateur work at its best is simple, unsophisticated and direct. Painting should be fun.

It is of course true that great artists achieve a kind of immortality in the works which they produce. The music they compose, the books and plays they write, the pictures they paint, provide, at least in the sort of time scale to which we are accustomed, a kind of extension to their lives on this Earth. For most painters, however, and certainly for most amateurs, the life of their paintings is likely to be as transient as their own. Happily the ephemeral nature of most works of art in no way detracts from the joy of making them. The primitive man smearing crude pigments on the walls of a crowded cave at Lascaux to depict so vividly one of the wild horses that he knew so well was not painting for posterity. He was painting in part for the crowd that pressed about him but even more urgently he was driven, as we his descendants are driven, to represent the likeness of something that he knew, and even more his own interpretation of such strength and beauty in his eyes.

89 *From my Bedroom Window*, VILLIERS DAVID
Painting should be fun

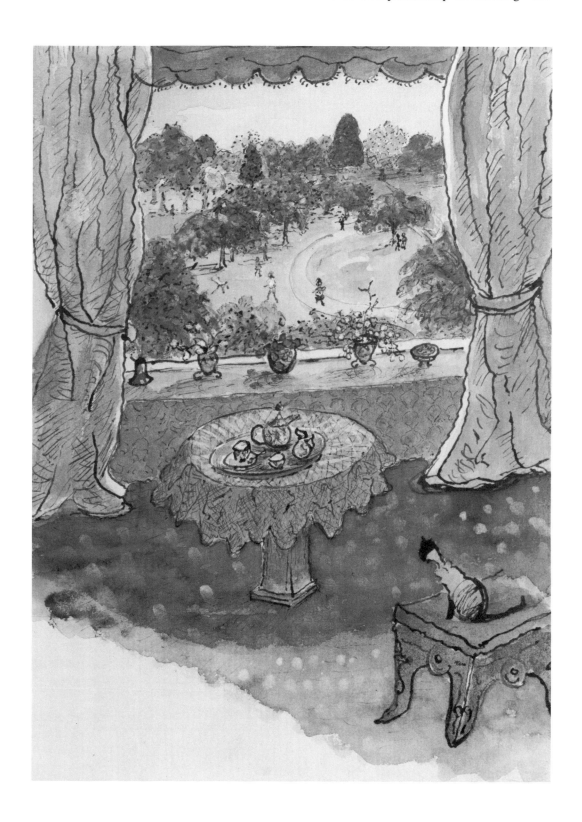

Centuries later an English poet, Robert Bridges, put into words the impulse that drove him and still drives his successors to seek to capture, however fleetingly, some part of the beauty of the world.

> I love all beauteous things,
> I seek and adore them;
> God hath no better praise,
> And man in his hasty days
> is honoured for them.
> I too will something make
> And joy in the making;
> Altho' tomorrow it seem
> Like the empty words of a dream
> Remembered on waking.

Our success in what we do matters less than our delight in doing it.

It remains, then, only to consider shortly the opportunities which are open to the amateur to enjoy with others the various aspects of his chosen occupation.

Painting is not, of course, in the main a spectator sport. It is essentially and pleasantly an occupation which one can enjoy on one's own. There are, I think, few better ways of finding refreshment of the spirit than being seated quite alone, looking closely at some pleasant scene and seeking to capture it in paint upon paper. Nevertheless most amateurs find an added delight, sometimes in exhibiting their works, sometimes in looking at the work of their contemporaries, in collecting watercolours or in working with others in sketching clubs, in art societies and so forth.

Many amateurs, of course, have never thought of exhibiting their work. Certainly no amateur should concern himself too much as to whether he shows or sells his watercolours. Nevertheless to exhibit a painting can be fun, and to sell one does give rise to feelings of quiet satisfaction that a painting which pleased you actually pleases someone else as well.

Don't start with a one-man show – it can be exhausting. It is necessary first to paint, to keep and to frame the necessary number (probably not less than forty) paintings of a standard satisfactory at least to the artist. It will mean hiring a room or a gallery, sending out large numbers of invitations, hanging the paintings and hoping for the best. An easier way is to get together with three or four other painters and to share the costs and of course the space within the gallery. For a start, however, the amateur would be wise to try submitting one or two of his paintings to a general exhibition. The Royal Academy is the oldest and most prestigious gallery we have. It exhibits and always has exhibited a substantial number of watercolours, but the competition to be hung is very great.

The original and oldest society concerning itself exclusively with water-

colours is the Royal Society of Painters in Water-Colours, now situated in London at the Bankside Gallery, 48 Hopton Street. It has a long and fascinating history. By the beginning of the nineteenth century the selling exhibition was to some extent replacing the more traditional forms of patronage by direct commission and the watercolour artists launched out upon their own exhibition. Prominent among those encouraging the new venture was John Varley. The Water-Colour Society's first exhibition attracted 12,000 visitors and this and subsequent exhibitions were given glowing reviews. A painting by John Varley could then be obtained at a price ranging from 1½ to 10 guineas. Paintings by this remarkable artist are today being sold at figures around £5,000. This Society, then, still thrives today. It is possible for an amateur to become a Friend of the Bankside Gallery for a subscription of £10 and be kept in touch with its activities which include exhibitions both by members of the Society and open exhibitions, art events of various kinds and opportunities of meeting and seeing demonstrations by the modern masters of the art of watercolour.

The Royal Institute of Painters in Water-colour was itself a breakaway from the Royal Society of Painters in Water-Colours, or the Old Water-colour Society as it is sometimes called. The Royal Institute holds Exhibitions at the Mall Gallery.

Beyond these there are a wide variety of exhibiting galleries and societies – some specialist such as Marine Painters, Sporting Paintings, the New English (one of the oldest and most famous), Miniaturists and many others. Many of these have pooled their resources to form the Federation of British Artists, operating from Carlton House Terrace and incorporating societies concerned with painting in oil and pastel as well as watercolour.

Your local library or art college will have details of art societies in your area. There are thus many opportunities, some national, some local, to meet and enjoy the company of other artists.

Collecting watercolours, contemporary or otherwise, is something that can be done at almost any level, for there are paintings, and good ones, available over a wide price range. Anyone contemplating starting a collection will do well to purchase *Collecting British Water Colours* by Derek Clifford. This enthralling book, which is well worth having whether one collects or not, includes a fairly comprehensive range of painters and breaks down the list by subject and by the area in which they painted. Importantly it also includes an invaluable list of galleries indicating the painters whose works are shown in them. This list is so valuable to all painters that I have, with the permission of the publisher and author, included an up-dated version of it in this book.

I have said that normally we amateurs paint alone. Painters do not, however, always paint alone. Painters of the great frescoes produced in

Renaissance Italy painted as a team, one man leading and laying down the main outline and strategy of the painting and others filling in the various aspects of the work under his direction.

Work on this scale is indeed rare today, but groups do from time to time join together to produce a painting. Children being taught art at school are sometimes encouraged to produce a mural on some convenient wall. A group of painters in Birmingham working under the auspices of the Manpower Services Commission recently produced a mural derived from Leonardo da Vinci's *Last Supper*.

The only joint painting that I can remember doing was a classical figure of a woman painted with Lady Bessborough, herself a talented amateur, on a wall of her lovely house at Stanstead Park. The wall chosen was in the Pool Room leading out to the swimming pool and we claimed that the figure we painted was drawn from the best points of the female guests gathered round the Pool. The painting is still there.

A more normal practice is for people to paint together in small informal groups or in sketching clubs, art societies and painting holidays. I recall happy hours spent painting with professional painting friends. I painted one of my earliest landscapes with Derek Hill from the steps of Sir Alfred Beit's house at Rusborough Park in the Irish Republic looking out over broad parklands to the distant Wicklow Hills. I remember many happy hours passed with Judy Cassab, the well-known Australian painter, in very different scenery around Sydney, and the help and encouragement she gave me. There is of course a long history of sketching clubs in Britain. Painters formed the habit of meeting in one another's houses, the host providing the refreshment and generally keeping the paintings. Sometimes models were brought in for the evening, chosen from talent in the locality and suitably rewarded. On other occasions a subject was chosen such as 'joy', 'sorrow', 'anger', 'childhood', and after a period for thought – sometimes longer than the time it took to do the painting – an interpretation was attempted.

Finally, as to holidays. There are firms who arrange holidays to suit a whole variety of occupations from bridge to fishing. Painting is no exception. Such holidays in which a group of people of like interest find themselves together in some well-chosen neighbourhood with professional guidance and instruction available can be extremely enjoyable. They are advertised both for inside this country and abroad for periods that vary from a few days to substantially longer, and are well worth trying.

Not so long ago my daughter Victoria (the one who was in her cradle page 22) left her two young sons and joined me in a week's painting holiday in Sussex. We were entertained in the student accommodation at the Agricultural College at Plumpton, and with some twenty-five other watercolourists painted the local scenery under arrangements made by

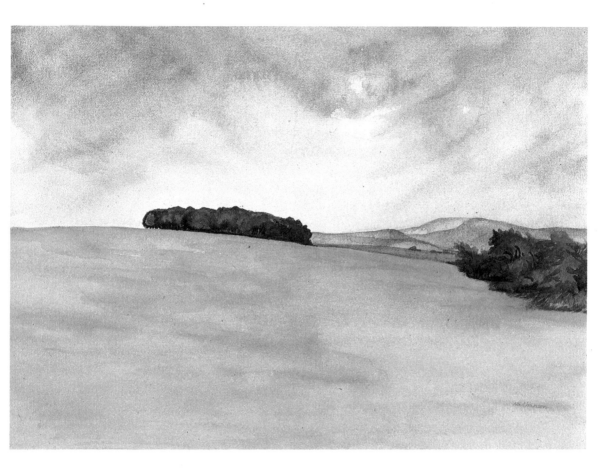

90 *Red Wood*, VICTORIA NATHANSON
High up on some shoulder of the Downs

Galleon Holidays and under the able guidance of John Seabrook. I have seldom enjoyed a holiday more – painting every day and joining in talk and discussion with kindred spirits in the evening. The weather, admittedly, was kind. The hospitality of the Agricultural College was excellent and the local scenery extremely paintable. To find oneself quietly painting with one's daughter high up on some shoulder of the Downs, to be absorbed in such a landscape, is in any event a thing of great enjoyment. There is a silence – no need to talk – a shared experience. Her painting *Red Wood* is a record of these hours and will perhaps provide a fitting conclusion to this book (**90**). I dedicate it to her as a token of a wonderful companionship and a shared delight in painting watercolours.

NOTES

THE AMATEUR

1 John Ruskin, *Stones of Venice* (vol III), Smith Elder, London, 1851–53
2 Kenneth Clark, *Ruskin Today*, John Murray, 1964

WATERCOLOUR

1 John Ruskin, *Lectures on Art*, Oxford University Press, 1870

LEARNING

1 Robert Emmons, *The Life and Opinions of Walter Richard Sickert*,
 Faber & Faber, 1941

DRAWING AS A MEANS

1 John Ruskin, *The Elements of Drawing*, Smith Elder, London, 1857
2 Solomon J. Solomon, *The Practice of Oil Painting and of Drawing as associated
 with it*, The New Art Library, 1910
3 Osbert Sitwell (ed.), *Sickert: A Free House*, Macmillan, 1947
4 Lillian Browse (ed.), *Sickert*, Faber & Faber, 1943
5 Osbert Sitwell (ed.), *Sickert: A Free House*, Macmillan, 1947

DRAWING AS AN ART

1 C.R. Leslie, *Memoirs of the Life of John Constable*, Phaidon Press, 1951
2 Omar Khayyam, *Rubaiyat*

PAINTING

1 John Ruskin, *Modern Painters* (vol V), Smith Elder, London, 1873
2 D.S. MacColl, *The Study of Brabazon*, Ernest Banister, 1910
3 Carter Ratcliff, *John Singer Sargent*, Phaidon Press, 1983

PAST MASTERS

1 Winston S. Churchill, *Painting as a Pastime*, Penguin Books, 1964
2 Kenneth Clark, *Landscape into Art*, John Murray, 1976
3 Ernest Short, *History of British Painting*, Eyre and Spottiswoode, 1953

THE VICTORIANS AND AFTER

1 John Ruskin, *The Eagle's Nest*, J.W. Lovell & Co., New York, 1886
2 Martin Hardie, *Water-colour Painting in Britain* (vol III), Batsford, 1968
3 *Antique Dealer and Collector's Guide*, April 1984

AMATEURS OF THE GOLDEN AGE

1 John Ruskin, *Lectures on Art*, Oxford University Press, 1870

THE CONTINUING TRADITION

1 Iolo Williams, *Early English Watercolours*, Connoisseur, 1952

DISTINGUISHED AMATEURS

1 Mary Soames, *Clementine Churchill*, Cassell, 1979
2 Winston S. Churchill, *Painting as a Pastime*, Penguin Books, 1964

THE DRAWING MASTERS

1 Samuel Pepys, *The Diary* (ed Rev. Smith), J.M. Dent, 1924
2 Kenneth Clark, *Ruskin Today*, John Murray, 1964
3 John Ruskin, *Stones of Venice* (ed and introduced Jan Morris),
 Faber & Faber, 1981

THE COMPANIONSHIP OF PAINTING

1 John Ruskin, *Modern Painters* (vol V), Smith Elder, London, 1873
2 David Cecil, *Library Looking Glass*, Constable, 1975

MUSEUMS AND ART GALLERIES
which have collections of British Watercolours

This is a brief indication of what is to be found in museums and galleries open to the public. Apart from these some public libraries, and semi-public institutions such as schools and colleges have collections and will normally arrange for them to be seen on application if given reasonable notice. Because of the size of many museum collections only a very small proportion is on view at one time. Few museums are able to maintain print rooms where students can see drawings and most have to make special arrangements, which they are usually ready to do if given reasonable notice. Museums in the main are understaffed and their store-rooms are over-crowded; this is not the fault of their dedicated personnel but of the financial support they are given – or not given.

Artists are named in these notes either if they are represented in quantity or if the gallery contains a particularly fine example, or in the case of rare artists any example at all. The absence of a name does not mean that the artist is unrepresented there.

> *small* – fewer than 500 drawings
> *medium* – 500 to 1,000
> *large* – 1,000 to 5,000
> *very large* – above 5,000

ABERDEEN. Art Gallery and Museums Department, School Hill. Small; general; Dyce, Wilkie, Turner.

ABERYSTWYTH, Dyfed. The National Library of Wales. Large; strong topographical bias; Rowlandson, M. Griffiths, John Ingleby, 'Warwick' Smith, etc.

ACCRINGTON, Lancashire. Haworth Art Gallery, Haworth Park. Small; general.

ALTON, Hampshire. Museum Annexe and Allen Gallery, 10–12 Church Street. Small; S.H. Grimm.

BANGOR, Caernarvonshire. Museum of Welsh antiquities, University College of North Wales, College Road. Drawings of Welsh interest.

BARNSLEY, Yorkshire. The Cooper Art Gallery, Church Street. Small; general; high quality; the Sir Michael Sadler Collection.

BATH. The Holburne of Menstrie Museum, Great Pulteney Street. Small; B. Barker, T. Barker, G. Clausen.

BATH. Victoria Art Gallery, Bridge Street. Small; general; strong topographical bias; Grimm, Hearne, Lens, T. Malton jnr, Rowlandson, Shepherd.

BEDFORD. Cecil Higgins Art Gallery, Castle Close. Medium; comprehensive collection of very high quality.

BELFAST. The Ulster Museum, Botanic Gardens. Large; general; William Conor, J. Moore, Andrew Nicholl, H. Fuseli, George Elgar Hicks, Susannah Drury; good representation of Irish and English watercolours from 17th century onwards.

BEMBRIDGE SCHOOL, Isle of Wight. The Ruskin Gallery. Ruskin.

BIRKENHEAD, Merseyside. The Williamson Art Gallery and Museum, Slatey Road. Medium; general.

BIRMINGHAM. Museums and Art Gallery, Chamberlain Square. Very large; comprehensive; includes works by leading watercolourists; Ruskin, D. Cox, J.R. Cozens, P. Sandby, F. Towne, de Wint, Girtin, etc.

BLACKBURN, Lancashire. Blackburn Museum and Art Gallery, Museum Street. Small; general; includes the E.L. Hartley Bequest; C.A. Hunt, Thorburn.

BLACKPOOL. The Grundy Art Gallery, Queen's Street. Medium; miscellaneous; some local topography; Spencelagh.

BOLTON, Lancashire. Museum and Art Gallery, Civic Centre. Medium; general; the aim is a comprehensive collection including contemporary work.

BOURNEMOUTH, Dorset. The Russell-Cotes Art Gallery and Museum, East Cliff. Large; comprehensive; some local topography.

BRADFORD, West Yorkshire. Art Galleries and Museums, Cartwright Hall, Lister Park. Large; comprehensive; local topography.

BRIDPORT, Dorset. Bridport Museum and Art Gallery, South Street. Small; William Walton.

BRIERLEY HILL, Staffordshire. Museum and Art Gallery, Moor Street.

BRIGHOUSE, Yorkshire. Public Library and Art Gallery. Small; general

BRIGHTON, Sussex. Brighton Art Gallery and Museum, Church Street. Medium; comprehensive; a large topographical section; representative 20th-century group.

BRISTOL. Bristol City Art Gallery, Queen's Road. Large; general, but not comprehensive; includes Braikenridge Collection of local topography; Muller, Johnson, Parsons.

BURNLEY, Lancashire. Towneley Hall Art Gallery and Museum, Towneley Hall. Small; general.

BURY, Lancashire. Bury Art Gallery and Museum, Moss Street. Small; general.

CAMBRIDGE. The Fitzwilliam Museum, Trumpington Street. Large; comprehensive; some of very high quality.

CANTERBURY, Kent. Public Library. Small; A. Nelson.

CARDIFF, South Glamorgan. The National Museum of Wales, Cathays Park. Large; comprehensive; strong local topographical interest; J.S. Davis, A. Parsons.

CARLISLE. Museum and Art Gallery. Small; general; strong in early 20th century;

Captain J.B. Gilpin, G. Sheffield, P. Nash, S. Bough, J. Carmichael, W.J. Blacklock, L. Clennell, W.H. Nutter, M.E. Nutter, R. Carlyle.

CHELTENHAM, Gloucestershire. Cheltenham Art Gallery and Museum, Clarence Street. Medium; general and topographical; R. Dighton.

COVENTRY, West Midlands. Herbert Art Gallery and Museum, Jordan Well. Large; Warwickshire topography; the most important collection of Rev. William Bree.

DERBY. Museums and Art Gallery. Small (no permanent display); J. Wright, Vawser, snr and jnr, M. Webster, J. Webber.

DONCASTER, Yorkshire. Doncaster Museum and Art Gallery. Very small; general; Crome, de Wint.

DORCHESTER, Dorset. The Dorset County Museum. Large; local topography.

DOUGLAS, Isle of Man. The Manx Museum. Medium; largely local topography; 'Warwick' Smith, M. Griffiths, A. Knox, J.M. Nicholson, J.H. Nicholson, W. Hoggatt.

DUNDEE. The Dundee Art Galleries and Museum, Albert Square. Medium; Brangwyn.

DUNDEE. The Orchar Art Gallery, Broughty Ferry. Scottish artists of the 19th century.

EASTBOURNE, Sussex. The Towner Art Gallery and Local History Museum, High Street, Manor Gardens. Large; original drawings by British book illustrators and contemporary artists; large local topographical section. Ravilious, Ardizzone, Grant, Vanessa Bell, Ivon Hitchens, Christopher Wood.

EDINBURGH, Scotland. Department of Prints and Drawings, National Galleries of Scotland. Medium; Vaughn Bequest of Watercolours by Turner; Helen Barlow Bequest of English Watercolours e.g. Barbizon school; comprehensive collection of Scottish watercolourists.

EXETER, Devon. Royal Albert Memorial Museum and Art Gallery, Queen Street. Medium; general; high quality; Towne, Prout, Merivale.

FOLKESTONE, Kent. The Museum and Public Library. Small; R. Reinagle, W. Collins, S. Prout, T. Cafe.

GATESHEAD. Tyne and Wear. The Shipley Art Gallery, Prince Consort Road. Small; general.

GLASGOW. Art Gallery and Museum, Kelvingrove. Large; general with a bias towards Scottish artists; Crawhall, P. Sandby, W.L. Leitch, Simpson, Millais, Conder, Cristall, Brangwyn, Melville.

GREAT YARMOUTH. Great Yarmouth Museums, 4 South Quay. Medium; local topography; sketches by brothers Joy.

HEREFORD. City Museum and Art Gallery. Large; general; Cox, Cristall, Girtin; a collection of work of the 'Old Sketching Society'.

HOVE, Sussex. Hove Museum and Art Gallery, 19 New Church Rd. Small.

HUDDERSFIELD, West Yorkshire. Huddersfield Art Gallery, Princess Alexandra Walk. Small; general; some 20th century.

HULL. The Ferens Art Gallery, Queen Victoria Square. Small; general including some good examples of prominent artists; local interest; Brangwyn.

IPSWICH. Museums and Galleries. Small; small collection of early English waterco-

lours and good collection of Second World War artists; Churchyard, Frost, Crome, Steer.

KEIGHLY, West Yorkshire. Keighly Art Gallery and Museum, Cliffe Castle. Small; chiefly by Yorkshire artists, or of local topography.

KETTERING, Northamptonshire. Alfred East Art Gallery, Sheep Street. Small; Sir A. East.

KIDDERMINSTER, Hereford. Wye Forest District Council Museum and Art Gallery, Market Street. Small; local topography.

LEAMINGTON SPA, Warwickshire. Leamington Spa Art Gallery and Museum, Avenue Road. Small; general; T. Baker.

LEEDS. City Art Gallery. Large; comprehensive; Cotman (including Bequest of S. Kitson).

LEICESTER. The Leicestershire Museum and Art Gallery, The New Walk. Fulleylove, Beaumont.

LEWES, Sussex. The Barbican House Museum, High Street. Small; limited to regional topography.

LINCOLN. The Usher Gallery, Lindum Road. Large; de Wint; large topographical section.

LIVERPOOL. The Walker Art Gallery, William Brown Street. Large; general; a large collection of local topography; A. Hunt, S. Austin, G. Jones, 'Warwick' Smith, Brangwyn, Huggins.

LONDON. The British Museum, Great Russell Street. Very large; comprehensive; (Turner collection moves to Tate Gallery in 1986).

LONDON. The Courtauld Institute Galleries, University of London, Woburn Square. Medium; comprehensive; including the Witt and Spooner and Princes Gate collections; Cozens, Gainsborough, Constable, Cox, de Wint, Ward, etc.; also Turner and Impressionists.

LONDON. The Imperial War Museum, Lambeth Road. Collection of the British War Artists.

LONDON. India Office Library. Very large.

LONDON. Leighton House Art Gallery and Museum, 12 Holland Park Road, Kensington. Small; miscellaneous; local topography; Leighton; Burne-Jones.

LONDON. Museum of London, Barbican. Large; London topography and social life; Rowlandson, T.M. Shepherd, etc.

LONDON. The National Maritime Museum, Romney Road, Greenwich. Very large; comprehensive but limited to marine interest and topography; the Van der Veldes, E.W. Cooke, Pocock, Rowlandson, Thornhill, West, Wyllie.

LONDON. Sir John Soane's Museum, 13 Lincoln's Inn Fields. Small miscellaneous collection includes J. Cozens; large collection of architectural drawings, many highly finished in watercolour; Adam, Dance, Soane, Gandy, etc.

LONDON. The Victoria and Albert Museum, Cromwell Road, South Kensington. Very large; comprehensive.

LONDON. South London Art Gallery, Peckham Road, Camberwell. Medium; general; topographical; strong 20th century.

LONDON. The Tate Gallery, Millbank. Large; comprehensive; Blake, Turner.

LONDON. The Wallace Collection, Hertford House, Manchester Square. Medium; Bonington.

LONDON, Wellington Museum, Apsley House, Hyde Park Corner. Small.

LONDON. The William Morris Gallery, Water House, Lloyd Park, Forest Road, Walthamstow. Medium; chiefly of artists connected with William Morris, e.g. Burne-Jones, Brangwyn; also Steer, Prout, Clausen, A. Goodwin, Rowlandson.

LONDON. John Evelyn Society's Museum, Ridgeway, Wimbledon. Local interest.

LONDON. Royal Society of Painters in Water-colours, Bankside Gallery, 48 Hopton Street, Blackfriars. Medium; comprehensive.

MACCLESFIELD, Cheshire. West Park Museum and Gallery, Prestbury Road. Small; mid-19th century; local topography.

MAIDENHEAD, Berkshire. The Henry Reitlinger Bequest, Oldfield, Riverside. Small; general.

MAIDSTONE, Kent. Museum and Art Gallery, St Faith's Street. Medium; W. Alexander, T. Pouncy, A. Goodwin, H. Bright, R.P. Noble, G. Pinwell; some contemporary.

MANCHESTER. The City Art Gallery, Mosley Street. Large; comprehensive; G. Barret jnr, D. Cox, Copley Fielding, W.H. Hunt, W.J. Müller, S. Palmer, S. Prout, 'Warwick' Smith, J.M.W. Turner, P. de Wint, etc.

MANCHESTER. The Whitworth Art Gallery, Oxford Road. Large; high quality; comprehensive; A. Cozens, J.R. Cozens, Girtin, Turner, Blake, Crome, etc.

MANSFIELD, Nottinghamshire. Mansfield Museum and Art Gallery, Leeming Street. Small; local topography; loan exhibitions in Buxton Gallery.

NEWARK-ON-TRENT. Nottinghamshire. Museum and Art Gallery, Appleton Gate. Small; local topography.

NEWCASTLE-UNDER-LYME, Staffordshire. The Borough Museum and Hobbergate Art Gallery, The Brampton. Small; 17th to 20th century collections of English watercolours; Rowlandson, Pritchett, Buss.

NEWCASTLE-UPON-TYNE. The Laing Art Gallery and Museum, Higham Place. Large; comprehensive; high quality; Richardson family, Luke Clennell, etc.

NEWPORT, Gwent. The Newport Museum and Art Gallery. Small; fairly comprehensive collection with many interesting items; Gastineau, Rooker, Hills.

NORWICH. The Norwich Castle Museum. Very large; general but predominantly Norwich School; J.S. Cotman.

NOTTINGHAM. The Nottingham City Museum and Art Gallery. Large; general; P. & T. Sandby, Bonington, S.W. Oscroft, H. Dawson.

OLDHAM, Lancashire. Art Gallery, Union Street. Medium; general; including the Charles E. Lees Bequest; strong contemporary.

OXFORD. The Ashmolean Museum of Art, Beaumont Street. Very large; comprehensive; fine quality; Girtin, Cotman, Palmer, L. Pisarro, Turner, etc.

PORTSMOUTH, Hampshire. City Museum and Art Gallery, Museum Road, Old Portsmouth. Small; small topography with some general interest; predominantly 20th century; Serres, Schetky, Clarkson-Stanfield.

PRESTON, Lancashire. The Harris Museum and Art Gallery, Market Square. Strong 19th and 20th century; Turner, Devis, Sandby, Palmer, David Roberts.

ROCHDALE, Greater Manchester. Art Gallery, Esplanade. Medium; emphasis on contemporary British Art.

SHEFFIELD, South Yorkshire. The Graves Art Gallery, Surrey Street. Notable collection of English watercolours; frequent loan exhibitions.

SOUTHAMPTON, Hampshire. The Southampton Art Gallery, Civic Centre. Large; general, but largely 20th century.

SOUTHPORT, Lancashire. The Atkinson Art Gallery, Lord Street. Small; general.

STAFFORD. William Salt Library.

STIRLING. The Smith Art Gallery and Museum, Albert Place. Small; general; the largest of J.D. Harding in Britain; Cox, T.M. Richardson, W.H. Hunt.

STOCKPORT, Greater Manchester. The War Memorial Art Gallery, Wellington Road South. Small; local topography.

STOKE-ON-TRENT, Staffordshire. The City Museum and Art Gallery, Bethesda Street, Hanley. Large; general.

STRATFORD-ON-AVON, Warwickshire. Shakespearian subjects; C. Cattermole.

SUNDERLAND. Tyne and Wear County Council Museums and Art Galleries, Borough Road. Medium; general; strong local topography; some 20th century besides the standard performers of early 19th century; J.W. Carmichael, Robson, Richardson.

SWANSEA. Glynn Vivian Art Gallery, Alexandra Road.

SWINDON, Wiltshire. The Swindon Museum and Art Gallery, Bath Road. Medium; general; mainly 20th century; Steer, Nash, Moore.

TUNBRIDGE WELLS, Kent. Royal Tunbridge Wells Museum and Art Gallery, Civic Centre. Small; local topography; C.T. Dodd and son.

WAKEFIELD, Yorkshire. Wakefield Art Gallery, Wentworth Terrace. Small; local topography; F. Hodgkins, W. Havell, Cromek, Bawden, Buckler, Vivian Pitchforth.

WARRINGTON, Cheshire. Municipal Museum and Art Gallery, Bold Street. Small; general; Sheffield, Brewtnall.

WHITBY, Yorkshire. Pannett Art Gallery, Pannett Park. Small; general; Chambers, Lawson, Carter, Weatherill.

WINCHESTER, Hampshire. The Winchester College Museum. Small; 18th and 19th centuries.

WOLVERHAMPTON, Staffordshire. The Municipal Art Gallery and Museum, Lichfield Street. Small; general; A. Parsons.

WORTHING, West Sussex. The Worthing Museum and Art Gallery, Chapel Road. Small; general; local topographical element; considerable 20th century representation; Wheatley.

YORK. York City Art Gallery, Exhibition Square. Medium; predominantly local topography; Henry Cave, Turner, Cotman, Girtin, F. Place.

The author and publishers are grateful to A & C Black (Publishers) Limited for permission to reproduce this Appendix from Derek Clifford's *Collecting English Watercolours*. It has been updated as far as possible.

BIBLIOGRAPHY

There are a vast range of books about the art of painting and an amateur can usefully spend time browsing through the art section of a bookshop to find what may suit his requirements and his pocket. Here is a short list of books which I have myself found useful.

Ashwin, Clive, *Encyclopaedia of Drawing*, Batsford, 1982
Battershill, Norman, *Painting and Drawing Water*, A&C Black, 1984
Dunstan, Bernard, *Starting to Paint Portraits*, Studio Vista, 1966
Hilder, Rowland, *Painting Landscapes in Watercolour*, Collins, 1983
Huntly, Moira, *Imaginative Still Life*, A&C Black, 1983
 Leisure Arts Book of Painting in Watercolours, The, Search Press, 1982
Saxton, Colin, *Art School*, Macmillan, 1981
Worth, Pitman, *The Practice of Watercolour Painting*, Pitman, 1977

The following books on the history of watercolour are recommended for any serious student of the subject.

Clarke, Michael, *The Tempting Prospect*, British Museum Publications, 1981
Clifford, Derek, *Collecting British Watercolours*, J. Baker (A&C Black), 1976
Hardie, Martin, *Water-colour Painting in Britain* (3 vols), Batsford, 1966–68
Williams, Iolo, *Early English Watercolours*, Connoisseur, 1952

LIST OF ILLUSTRATIONS

1 *Interior, St Paul's*, Sir William Eden. Private Collection, photograph Jason Shenai

2 *S. Moise*, Lord Thorneycroft. Private Collection, photograph Jason Shenai

3 *Landscape*, A. van Dyck. The Barber Institute of Fine Arts, The University of Birmingham

4 *The Leaning Towers, Bologna*, R.P. Bonington. Reproduced by permission of the Trustees of the Wallace Collection

5 *A Lady at her Toilet*, R.P. Bonington. Reproduced by permission of the Trustees of the Wallace Collection

6 *Sketches*, Lord Thorneycroft. Photograph Jason Shenai

7 *The Estuary*, Vivian Pitchforth. Private Collection, photograph Jason Shenai

8 *Venetian Sketch*, Lord Thorneycroft. Photograph Jason Shenai

9 *The Jockey*, Edgar Degas. Ashmolean Museum, Oxford

10 *The Elm Trees, Kirby Road, Nr Frinton, Essex*, Robert Alexander. Michael Parkin Fine Art

11 *Minister in Search of a Style*. Daily Express

12 *Seated Model*, Vivian Pitchforth. The Tate Gallery, London

13 *Plaster Cast*, Solomon J. Solomon. Photograph Jason Shenai

14 *Squared-up drawing for 'Ennui'*, Walter Sickert. Ashmolean Museum, Oxford

15 *View near Cairo*, Edward Lear. The Tate Gallery, London

16 *Sketchbook*, Graham Sutherland. © Cosmopress, Geneva and ADAGP, Paris, 1985

17, 18, 19, 20 *Sketches*, Lord Thorneycroft. Photographs Jason Shenai

21,22 *Letters to the author*, John Ward. Photograph Jason Shenai

23,24 *Christ appearing to St Bernard*, School of Perugino. Witt Library.

25 *Apollo Playing a Musical Instrument*, Raphael. Collection J-B. Wicar

26 *Detail of 25 from fresco 'Parnassus'*, Raphael. Palais des Beaux-Arts, Lille

27 *Monuments, Yarnton*, John Piper. The Tate Gallery, London

28 *Turner's House at Twickenham*, Sir Hugh Casson, J.M. Dent & Sons Ltd

29 *The Ballad Singer*, Thomas Rowlandson. Collection Richard Nathanson

30 *Haresfoot Park, Near Berkhampstead, Herts*, Wilson Steer. Victoria & Albert Museum

31 *Gardenias in a Blue Vase*, Lord Thorneycroft. Private Collection, photograph Jason Shenai

32 *The First Rate taking in Stores*, J.M.W. Turner. The Trustees, The Cecil Higgins Art Gallery, Bedford, England

33 *Valley Farm*, John Constable. Fitzwilliam Museum, Cambridge

34 *Flatford Lock*, John Constable. Fitzwilliam Museum, Cambridge

35 *Seated Cat*, Gwen John. Courtesy Anthony d'Offay Gallery, London

36 *Sleeping Girl*, Rembrandt. British Museum

37 *Calle Arco Detto Bon*, Lord Thorneycroft. Photograph Jason Shenai

38 *Little girl in checked coat with woman in black*, Gwen John. Courtesy Anthony d'Offay Gallery, London

39 *Still Life*, David Cox. The Tate Gallery, London

40 *Spitz-Hüte*, Paul Klee. Christie's Colour Library

41 *View, North Bank of Thames*, Wenceslaus Holler. Reproduced by gracious permission of Her Majesty The Queen

42 *Study for a Landscape*, John Constable. Victoria
& Albert Museum, photograph Jason Shenai

43 *The Shadowed Road*, John Crome. Victoria &
Albert Museum

44 *Wooded Landscape*, John Sell Cotman. Victoria
& Albert Museum

45 *The Lake of Albano and Castle Gandolfo.
Evening*, John Robert Cozens, Martyn Gregory
Gallery, London

46 *Venice*, J.M.W. Turner. British Museum

47 *Lake Maggiore*, Francis Towne. Christie's
Colour Library

48 *Study for 'Christ in the House of his Parents'*,
John Everett Millais. The Tate Gallery, London

49 *Bravo Toro*, Arthur Melville. Victoria & Albert
Museum, photograph Jason Shenai

50 *Chinese Goose*, Joseph Crawhall. The Burrell
Collection, Glasgow Art Gallery & Museum

51 *Loveday and Ann: Two Women with a Basket of
Flowers*, Frances Hodgkins. The Tate Gallery,
London

52 *River Bed*, John Singer Sargent. By permission
of the Trustees of the Royal Society of Painters in
Water-Colours

53 *Mother and Child*, James Whistler. Victoria &
Albert Museum

54 *Indian Religious Man*, John White. British
Museum

55 *Mounk*, Edward Barlow. National Maritime
Museum

56 *Peterborough House from Millbank*, Francis
Place. Victoria & Albert Museum

57 *Road Leading to a Church*, William Taverner.
British Museum

58 *Landscape near Fetcham*, Dr Thomas Monro.
Private Collection, photograph Jason Shenai

59 *Crossing a Stream*, George Beaumont.
Beaumont Collection

60 *Duke of Norfolk*, Marquis of Townshend.
Rudolf Ensmann

61 *Sketch for 'Reading the Will'*, Henry Bunbury.
British Museum

62 *Near Duxford, Cambridgeshire*, Amelia Long,
Lady Farnborough. Christie's

63 *Plan of Campaign*, Catherine Maria Fanshawe.
British Museum

64 *Two Figures by a Lake*, Rev. William Gilpin.
Private Collection, photograph Jason Shenai

65 *The Erme, near Ivybridge, Devon*, John White
Abbott. Christie's Colour Library

66 *Landscape*, Francis Tomline. Author's

Collection, photograph Jason Shenai

67 *Conway Castle*, Earl of Aylesford. Aylesford
Collection, Lionel Photography

68 *A View of Highgate from Hampstead Heath*,
William George Jennings. Krios Gallery

69 *Landscape*, Minny Pell. Private Collection,
photograph Jason Shenai

70 *Dr Crotch playing Mozart*, John Constable.
Norwich Record Office

71 *Study for a Mural*, Lady Waterford. Author's
Collection, photograph Jason Shenai

72 *The Pink Palace*, Hercules Brabazon. The Tate
Gallery, London

73 *Landscape, Northumberland*, Lord
Northbourne. Private Collection, photograph
Jason Shenai

74 *The Pewsey Vale*, Rupert Butler. Private
Collection, photograph Jason Shenai

75 *Woman Sketching*, Mildred Anne Butler.
Christie's Colour Library

76 *Melting Ice*, Carolyn James. Private Collection

77 *Magnolia*, Winston Churchill. Private
Collection, photograph Jason Shenai

78 *Installation of a Weapon on a Ship*, Prince
Rupert. British Museum

79 *Design for a Cottage*, George III. Reproduced
by gracious permission of Her Majesty The
Queen

80 *Landscape*, Princess Elizabeth. Reproduced by
gracious permission of Her Majesty The Queen

81 *Vicky, 1841*, Queen Victoria. Reproduced by
gracious permission of Her Majesty The Queen

82 *Victoria*, Queen Victoria. By kind permission of
the Marquess of Tavistock, and the Trustees of
the Bedford Estates

83 *Hanseatic Merchant, after Holbein*, Princess
Victoria. Sotheby's

84 *Reminiscences*, Princess Louise. Reproduced by
gracious permission of Her Majesty The Queen

85 *Balmoral under Snow*, Queen Victoria.
Reproduced by gracious permission of Her
Majesty The Queen

86 *Broadlands*, Prince Charles. Private Collection,
photograph Jason Shenai, by gracious permission
of His Royal Highness Prince Charles

87 *Two Musicians*, John Malchair. British Museum

88 *Gothic Window, Venice*, John Ruskin. British
Museum

89 *From my Bedroom Window*, Villiers David

90 *Red Wood*, Victoria Nathanson. Collection
Richard Nathanson

INDEX

Page numbers in *italic* type indicate illustrations. A letter 'e' after a page number indicates an epigraph.

Abbott, John White, 104; *106*
Albert, Prince, 130
Alexander, David, 101
Alexander, Robert Graham Dryden, 29, 117; *27*
Alexander, William, 99
Alexandra, Queen, 132
alla prima, 43
Allingham, Helen, 80, 85
Allingham, William, 80
Alpert, Henry C., 107
amateur, the, 11-16, 26, 138-43; *see also under* watercolourists
Arnold, George, 99
art school, *see* tuition
Arundel, Thomas Howard, Earl of, 70
avant-garde painting, 66-7
Aylesford, Earl of, 109-11, 136; *109*

Bacon, Francis, 34
Balmoral, 129
Bampfylde, Coplestone Warne, 105
Bankside Gallery, 141
Barlow, Edward, 92-3; *91*
Barlow, Francis, 94
Beaumont, Sir George Harland, 97-9, 100, 136; *98*
Beckford, William, 100
Bessborough, Lady, 142
Bessborough, William Ponsonby, second Earl of, 95
Biggleston, Ken, 124
Blake, William, 43e, 43, 76
board, 49-51
Bonington, Richard Parkes, 20, 76; *19*
Boudin, Eugène, 18
Brabazon, Hercules, 48, 81, 85, 116-17; *115*
Brangwyn, Sir Frank, 81

Bridges, Robert, 140
brushes, 24, 39, 51
Bunbury, Henry, 102; *102*
Butler, Mildred Anne, 113-14; *119*
Butler, Rupert, 120-1; *118*

Callow, William, 80
Canning, Lady, 114, 128, 132
Carlisle, George James Howard, Earl of, 114
Cassab, Judy, 142
Casson, Sir Hugh, 51; *50*
Cézanne, Paul, 47, 51
Chardin, J.B.S., 65
Charles I, King, 70
Charles II, King, 70, 125
Charles, Prince, 132; *131*
Cholmeley, Mrs, 100
Christ appearing to Saint Bernard (School of Perugino), 44; *44*
Christ's Hospital, 133
Churchill, Sir Winston, 24, 68e, 124-5; *123*
Clark, Kenneth, 136-7
collecting, 141
Collier, Thomas, 81-2
Collins, William, 99
colour, 53-5
Conquest, 124
Constable, John, 43e, 43, 59, 73, 99, 99-100, 108, 134; *59, 60, 71, 111*
Cook, Captain James, 92
Cotman, John Sell, 12, 73, 77, 100; *74*
courage, importance of, 48
Cox, David, 65, 73, 108, 134; *65*
Cozens, Alexander, 74, 97, 100, 126, 133, 134
Cozens, John Robert, 74, 98, 99, 100; *75*
Crawhall, Joseph 'Creeps', 82-3; *83*
Crome, John, 72, 73, 100; *72*
Crotch, Dr William, 109, 112

Daily Express, 30

Dali, Salvador, 13
Daniell, Samuel, 99
Darwin, Charles, 92
David, Villiers, 138; *139*
De Wint, Peter, 12, 73, 134
Derby, Lord, 12
Devis, Arthur, 69
Dickens, Charles, 78
drawing, 31, 32-42, 43-7, 48

Earle, Augustus, 92
Eden, Sir William, 119-20; *ii*
Eldridge, Harry, 99
Elizabeth, Princess (daughter of George III), 128; *128*
Elmore, Alfred, 77
Emerson, Ralph Waldo, 16
equipment, 24, 39, 49-51
etching, 94, 101
exhibiting, 140-1

Fanshawe, Catherine Maria, 102; *103*
Fantin-Latour, Henri, 65
Farnborough, Lady, *see* Long, Amelia
Fawkes family, 55-7, 100
Federation of British Artists, 141
First Rate Taking in Stores, The (Turner), 55-6; *56*
Fisher, Sir George Bulteel, 134
Flatford Lock (Constable), 59; *60*
Foster, Birket, 80
Frankland, Thomas, 136
fresco painting, 44
Frogmore, 128
Fuseli, Henry, 69

Gainsborough, Thomas, 69, 97, 126
George III, King, 126; *127*
Gilpin, Rev. William, 104-5; *104*
Girtin, Thomas, 12, 73, 97, 100, 134
Glasgow Art Gallery, 13
Glasgow School, 81
Glover, John, 107, 134
Glover, William, 107
Gooch, John, 136
Gravett, Colonel, 100
Greaves, Walter, 32
Green, Amos, 107
Greville, Charles, 100

Hall, Mary Newpold Patterson, 57
handicapped painters, 124
Harcourt, Earl of, 100
Hardie, Martin, 80, 88
Hare, Augustus, 114

Harvey, Thomas, 100
Heatherley School of Fine Art, 28
highlights, 53
Hill, Derek, 142
Hodges, William, 92
Hodgkins, Frances, 85; *84*
Hogarth, William, 69
Holder, Eric, 80
holidays, painting, 22-4, 142-3
Hollar, Wenceslaus, 70; *70*
Holworthy, James, 107
Hulme, Ursula, 124
Hunt, William, 80
Hunt, William Holman, 78

Impressionists, 46
Institute of Contemporary Art, 66

James, Carolyn, 124; *122*
James, Henry, 138
Jennings, William George, 108; *110*
John, Gwen, 60, 64, 85; *61, 64*
Jongkind, J.B., 18

Kauffmann, Angelica, 85
Keating, Tom, 29-30
Keene, Charles, 82
Klee, Paul, 67; *66*
Kneller, Sir Godfrey, 69
Knight, John Bavestock, 105
Knight, Dame Laura, 85
Knowsley, 12

Lake of Albano and Castle Gandolfo. Evening (J.R. Cozens), 74; *75*
Lamb, Lady Caroline, 95
landscape painting, 39, 58, 69, 95, 100, 104-5
Lascelles, Lord, 100
Le Marchant, Major General Gaspard, 133-4
Lear, Edward, 12, 37; *37*
learning, *see* tuition
Leitch, William Leighton, 128
Lely, Sir Peter, 69
Levin, Bernard, 78-9
life drawing, 33, 35
light and shade, 53-5
Lodge, William, 94
Long, Amelia, 100, 102; *103*
Louise, Princess, 130; *130*

MacColl, D.S., 48
Malchair, Dr John, 97, 100, 112, 135-6; *135*
Marmottan, Musée, 17-18
Martens, Conrad, 92
Matisse, Henri, 59

Maugham, W. Somerset, 114
media, choice of, 17, 49
Melville, Arthur, 81; *82*
Millais, John Everett, 78; *79*
Monck, Lady Mary, 134
Monet, Claude, 17-18
Monro, Dr Thomas, 12, 97, 100; *96*
Morisot, Berthe, 18
Morris, Jan, 137
Mountbatten, Lord, 30

Napier, General, 134
Nathanson, Victoria, 22, 142-3; *143*
National Gallery, 99, 134
Nicholson, Francis, 134
Northbourne family, 120
Northbourne, Walter James, later Third Baron, 120; *118*

oil painting, 17, 35, 43, 48, 55

paintbox, 39, 51
painter, qualities needed in, 26, 48, 58
painting, 67; *see also* landscape painting; oil painting; watercolour; *and other headings*
paintings, importance of studying, 13, 25, 26, 29-30, 35, 38, 67, 68, 77, 121
Palmer, Samuel, 76
paper, 49
Parnassus (Raphael), 45; *45*
patrons, patronage, 95-100, 113
Payne, William, 134
Peacham, Harry, 122e
Pell, Margaret Matilda (Minny), 108-9; *110*
Pepys, Samuel, 133e, 133
Pickering, George, 107
Piper, John, 47; *46*
Pitchforth, Vivian, 20-1, 33, 35; *22, 34*
Place; Francis, 70, 93-4; *93*
portrait painting, 60, 64
Poynter, Sir Edward, 29
Pre-Raphaelite Brotherhood, 78-9
Price, Rev. William, 109
Pym, Francis, 108

Raleigh, Sir Walter, 89
Raphael, 45; *45*
Reeve, William, 20, 70, 100
Rembrandt, 61, 67; *62*
Rossetti, Dante Gabriel, 78, 79
Rowlandson, Thomas, 51, 104; *52*
Royal Academy, 140
Royal Family, 125-32
Royal Institute of Painters in Water-colour, 141
Royal Military Academy, 133

Royal Society of Painters in Water-Colours, 141
Rupert, Prince, 125; *125*
Ruskin, John, 11e, 15, 17e, 32e, 78e, 78, 88e, 114, 116, 117, 136-7, 138e, 138; *137*

Salt, Henry, 107
Sandby, Paul, 12, 70, 73, 100, 133, 134
Sargent, John Singer, 57, 85-6, 116; *86*
Seabrook, John, 143
Seago, Edward, 39
shadows, 55
Sickert, Walter, 26e, 35, 36-7, 81, 89; *36*
Signac, Paul, 18
sketching, sketchbooks, 24, 37, 39, 41; of the masters, 35, 38
Skippe, John, 136
Slade School, 29
Sleeping Girl (Rembrandt), 67; *62*
Smollett, Tobias, 95
Solomon, Solomon J., 33; *34*
Spitz-Hüte (Klee), 67; *66*
Stanstead Park, 142
Steer, Wilson, 51, 85; *52*
still life, 65
Stubbs, George, 69
Study for a Landscape (Constable), 73; *71*
style, individual, 30-1
Sutherland, Graham, 38, 67; *38*

Taverner, William, 95; *94*
teaching, *see* tuition
technique, 58, 67
Thorneycroft, Lord, 12-13, 15, 22-4, 26, 30-1, 33, 39-41, 51, 124, 133, 142-3; *14, 21, 23, 31, 40, 54, 63*
Thorneycroft, Victoria, *see* Nathanson
Tomline, Frances, 107; *107*
Tonks, Professor, 117
Towne, Francis, 74, 105; *76*
Townshend, Marquis of, 101; *101*
'Très Riches Heures du Duc de Berri, Les', 18
tuition, art school, learning, 15, 26-31, 53, 133-7
Turner, Dawson, 100
Turner, J.M.W., 12, 33, 55-7, 73, 76-7, 97, 100; *56, 75*

Valley Farm, The (Constable), 59; *59*
van Dyck, Anthony, 20; *18*
Varley, Cornelius, 12
Varley, John, 12, 73, 100, 134, 141
Venetian school, 47
Venice, 15, 63
Vertue, George, 95
Victoria, Princess (daughter of Queen Victoria), 130; *130*

Victoria, Queen, 128-30; *129; 131*
Victorian era, 80-1
Virginia, 89
Vuillard, Jean Édouard, 65

Walker, Ethel, 85
Wallace Collection, 20
Walters, John, 28
Ward, John, 42; *42*
watercolour, 17-25, 31, 47, 48-57, 64, 67
 avant-garde, 66-7
 difficulty, 17, 18, 48
 history, 18-20, 68-121
 oil painting compared, 17, 35, 48, 55
 two types of, 51

watercolourists
 amateur, 87, 88-137
 professional, 69-87, 96-100, 133-7
Waterford, Lady, 114-16; *115*
Waugh, Evelyn, 17
West Country painters, 105
Westall, Richard, 128
Westminster, Palace of, 41
Whistler, James Abbott McNeill, 32, 48, 85, 86, 89;
 87
White, John, 89-92; *90*
Wilkie, Sir David, 99
Williams, Iolo, 88, 113e
Wilson, Richard, 135
women, as painters, 85, 102
Wren, Sir Christopher, 133